THE BRANCACCI CHAPEL
FLORENCE

THE BRANCACCI CHAPEL

FLORENCE

Andrew Ladis

GEORGE BRAZILLER NEW YORK

Acknowledgments

No book, not even a small one, enters the world alone and without help, but this must be particularly true of one about a subject as large, as contentious, and as dangerously alluring as the Brancacci Chapel. For objections and advice, disagreements and suggestions, warnings and favors too many to list, my thanks go to: Paul Barolsky, James Beck, Eve Borsook, Yvonne Boyer, Bruce Cole, Leonard Folgarait, Phyllis Rambin, Christine Smith, Gail Solberg, Jan Ziolkowski. Because this book took shape in Florence, I also have the great pleasure of thanking Walter Kaiser and the staff of Villa I Tatti, who, as always, made my visit thought-enhancing. And because this book was begun in a moment of trial far away, I have others, nameless only here, to remember for more kindnesses than I even know.

For V, who knows the difference

—*Andrew Ladis*

Published in 1993 by George Braziller, Inc.
Texts copyright © George Braziller, Inc.
Illustrations copyright © Scala Archives, New York
Figure 2 is reproduced by courtesy of Olivetti, Italy.

For information, please address the publisher:

George Braziller, Inc.
60 Madison Avenue New York, NY 10010

LIBRARY OF CONGRESS CATALOGING-IN-PUBLICATION DATA:
Ladis, Andrew, 1949-
 The Brancacci Chapel, Florence / Andrew Ladis
 p. cm.—(The Great Fresco Cycles of the Renaissance)
 Includes bibliographical references and glossary.
 ISBN 0-8076-1311-8 (cloth)
 1. Mural painting and decoration, Italian—Italy—Florence.
 2. Mural painting and decoration, Renaissance—Italy—Florence.
 3. Capella Brancacci [Santa Maria del Carmine (Church: Florence, Italy)]
I. Title. II. Series.
ND2757.F5L34 1993 93-6995
751.7'3' 094551—dc20 CIP

Book Design: Adrienne Weiss
Printed by Arti Grafiche Motta, Arese, Italy

Contents

The Art of Renaissance Fresco Painting

From about 1400–1600, the art of mural painting flourished in Italy to an extent unparalleled anywhere since the remote days when men and women lived in caves. Indeed, when we think of the art of the Italian Renaissance, we tend to think of paintings that are on walls, or what are more commonly called frescoes. How very different our sense of the Rennaissance would be if Michelangelo had not painted the Sistine Ceiling, Giotto the Scrovegni Chapel, or Masaccio the *Tribute Money* in the Brancacci Chapel. Murals, although enjoying wide popularity in antiquity and painted continuously throughout the Middle Ages, came to occupy an especially prominent place in the physical fabric of Renaissance Italy. They were found in churches, on the façades of buildings, in the meetinghouses of religious corporations, in the private palaces of the well-to-do, in civic buildings of all kinds, over city gates, along country byways and street corners. Even after the destruction of countless works of art over the years, the number of mural paintings in Italy is still staggering.

Clearly, the cultural climate was hospitable. It is notable that the rise of fresco painting in Italy coincided with the emergence of the Italian city-state and with the growth of the mendicant orders, the Franciscans and the Dominicans, in the thirteenth century. The new economic power of the towns resulted in greater and more widespread capital that might be spent on works of art, and the new orders no doubt stimulated demand, but why did Italians favor frescoes and not the other great forms of monumental decoration, mosaics and stained glass? To be sure, fresco painting offered aesthetic and practical advantages over mosaics and stained glass; besides being generally less expensive to create, less expensive to maintain, and no less durable than stained glass or mosaic, it was more legible and more readily lent itself to the realistic art of the Italian Renaissance. Whereas

stained glass and mosaics either replaced or dissolved walls and dematerialized form, frescoes made it easier to emphasize the solidity of things. Moreover, the plaster on which colors are applied is extremely hard and durable, and its crystalline structure is highly reflective, giving the colors a remarkable luminosity. This colored surface, if kept free from moisture and chemicals in the wall and from pollution (including the carbon dioxide we exhale), will remain bright and clear far longer than any painting in oil.

In the middle of the sixteenth century, the painter, architect, and writer Giorgio Vasari praised the virtues of fresco painting, particularly its durability and luminosity, but he also described it as the most difficult as well as the noblest kind of painting. When we look at the still-fresh colors spread across the often vast surfaces of Renaissance murals, it is easy to forget how much planning as well as painstaking, sometimes dangerous labor went into their making. We have to imagine the walls of the Sistine Chapel or the choir of Santa Maria Novella in Florence as rough masonry in order to appreciate a singular fact: that more than any other pictorial art, fresco painting approximates architecture and poses almost as many technical obstacles. The surface of a wall of masonry is not intrinsically hospitable to paint. It was necessary to make it both suitable for the painter's work and durable, and if the wall was large, this in itself might be a task requiring considerable time and more than a few hands.

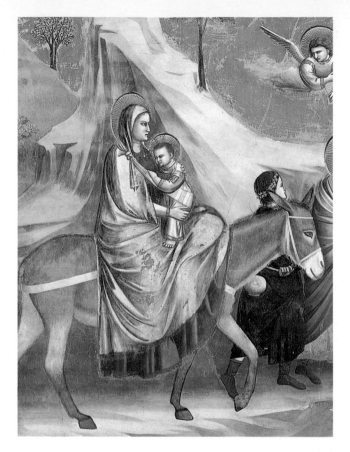

Fig. 1. Giotto, detail, *The Flight into Egypt* (c. 1305), Scrovegni Chapel, Padua. The blue of the Virgin's mantle at the center of the composition, painted *a secco*, has almost entirely fallen off, revealing the sinopia below. The area of the sky, painted with the same blue, has also suffered losses.

One of the painter's first requirements was scaffolding, which perforce had to be as broad as the wall and comfortable enough to accommodate workmen, tools, and materials. Once the scaffolding was ready, the painter and his collaborators applied a coat of coarse plaster known as the *arriccio*. Its roughness, or "tooth," was essential, or else the actual painting surface, namely the final, smooth layer of plaster, known as the *intonaco*, would not adhere. Once the *arriccio* was laid and doubtless after the painter had made careful measurements and preparatory drawings, he and his assistants could proceed to transfer the decorative scheme to the wall. To do this, the painter drew directly on the *arriccio,* first usually with charcoal and then, once satisfied with the general layout, usually with red ochre dissolved in water. Once this brush drawing, or sinopia, was dry, the charcoal might be brushed off, leaving the second drawing to serve as a guide. Sinopie were drawings that were never meant to be seen by anyone other than the artists. They were made to give the artist and his assistants an indication of the overall effect of a composition; thus, many of them are extremely sketchy (fig. 1).

True, or *buon,* fresco required painting on wet plaster. When pigment suspended in lime water was applied to a surface of wet plaster, it penetrated it and, as the plaster dried, the color permanently bonded to it.

The painter applied the thin final layer of plaster, the *intonaco*, one section at a time, generally beginning at the top of the wall and working down so that drips and runs would fall on the unpainted surface below. The size of each patch, or *giornata*, depended on how long it would take to paint it before the plaster dried too much, so details such as heads, which required more work and time, tended to be painted on smaller *giornate* than less detailed features such as backgrounds. As each patch of *intonaco* was applied over the *arriccio*, the sinopia was gradually covered from view. The irregular patchwork of painted *giornate*, occasionally visible with a naked eye or under a raking light, can be mapped out and is a characteristic feature of paintings in true fresco (fig. 2). It was, however, never the painter's intent that these sutures be visible. He tried to paint each section, particularly if using the same color, at the same stage of wetness, because pigment applied to a patch drier or wetter than another will have a different tonality. An error, once made, could not be fully corrected except by chipping out the section and applying a fresh coat of *intonaco.*

No mural was painted entirely in true fresco, but instead in a combination of techniques. Some pigments, such as blue, could only be applied *a secco*, that is, using a binder and painting on dry plaster, and many fine details of costume and anatomy were often under-

taken after the *intonaco* was dry. As a result, however, such superimposed details and the blue backgrounds of many murals have flaked off. A mural undertaken entirely *a secco* was easier to paint, since it freed the artist from the pressure of painting in a race against time, but it was also less permanent and less luminous than one done in true fresco.

Toward the middle of the fifteenth century, as painters sought ever more complex spacial effects, they began to develop their ideas more in the studio and less on the wall. The intimate relationship between the mural and its architectural setting began to change, as painters increasingly treated their murals like easel paintings to be "hung" rather than as images harmoniously integral to the space. One sign in this shift in attitude was the adoption of cartoons, that is, drawings made to the exact scale of the intended paintings. Having worked out, for example, a difficult problem of foreshortening in the comfort of the studio, the painter could transpose his solution to the large scale of the cartoon, which could then be placed directly on the *intonaco* and precisely transferred to it, either by means of a stylus used to score the contours or by means of charcoal dusted over the drawing whose outlines were pricked with small holes. When the cartoon was removed, the painter could proceed to paint with the aid of dotted lines of charcoal or lines scored into the surface. The cartoon was a device that made fresco painting more predictable. Working close to the surface, wielding large brushes, creating forms that were often larger than himself, and painting on plaster that was drying with each passing minute, the painter need not worry whether the swift action of his hand would result in an accurate rendering of a particularly difficult effect. Without cartoons a work such as Michelangelo's Sistine Ceiling would no doubt look very different, but such changes in working practice came at a cost: the nature of the relationship between the painter and his medium became less direct than in the days of Giotto and Masaccio. Over time painters increasingly avoided the demands and the technique of true fresco, and by the seventeenth century the golden age of the medium was no more.

Following pages

12-13: fig. 2, map of the *giornata* of
the *Tribute Money* with numbers
indicating the possible order in which
the patches were painted.

14-15: View of the Brancacci Chapel
16-17: Plan of the Brancacci Clapel

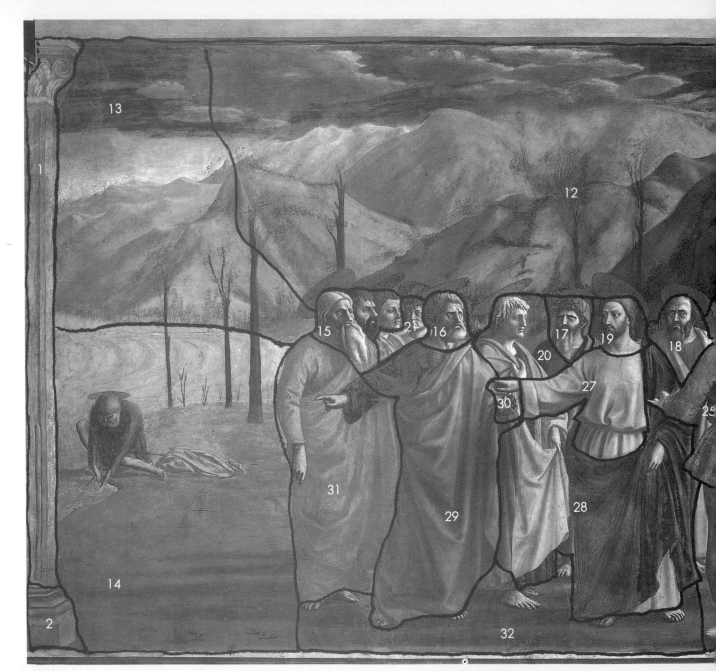

Figure 2

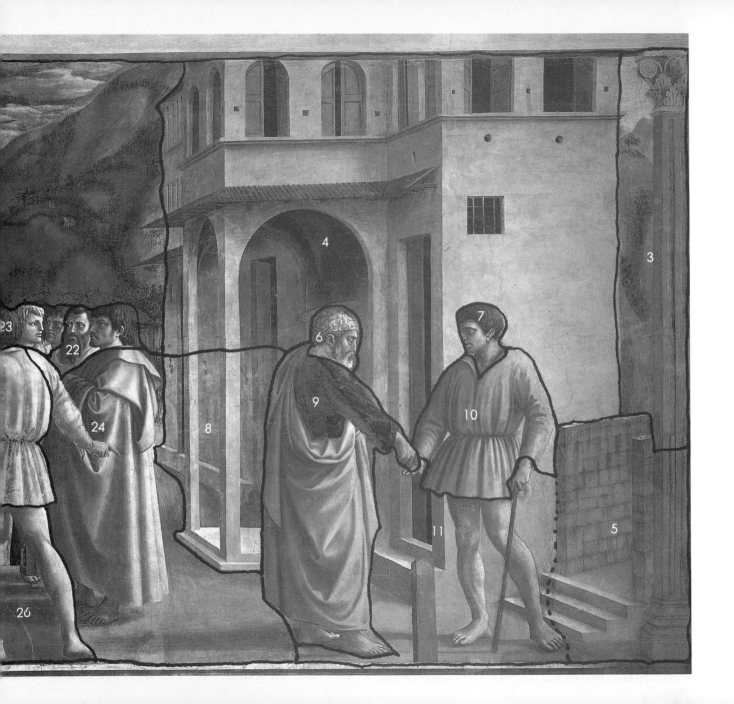

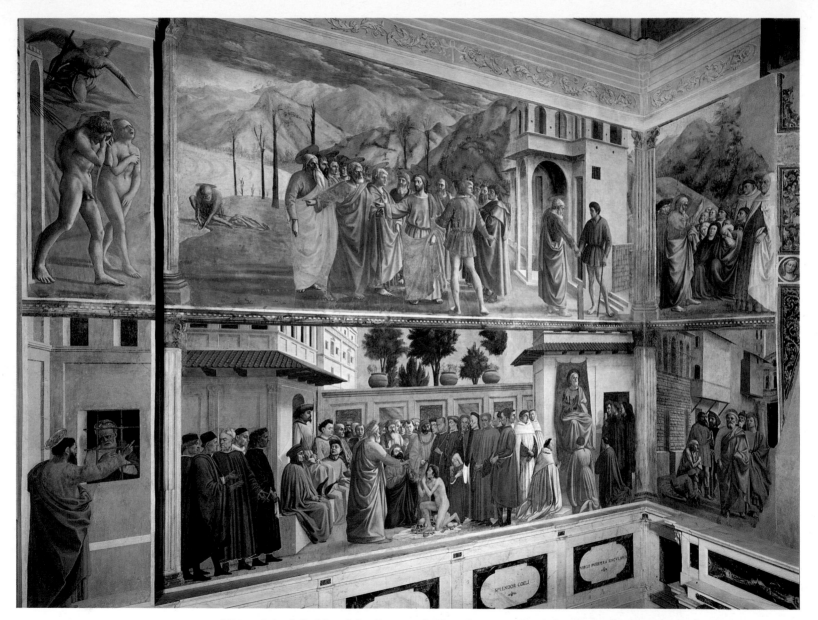

View of the left side of the Brancacci Chapel as seen from the altar

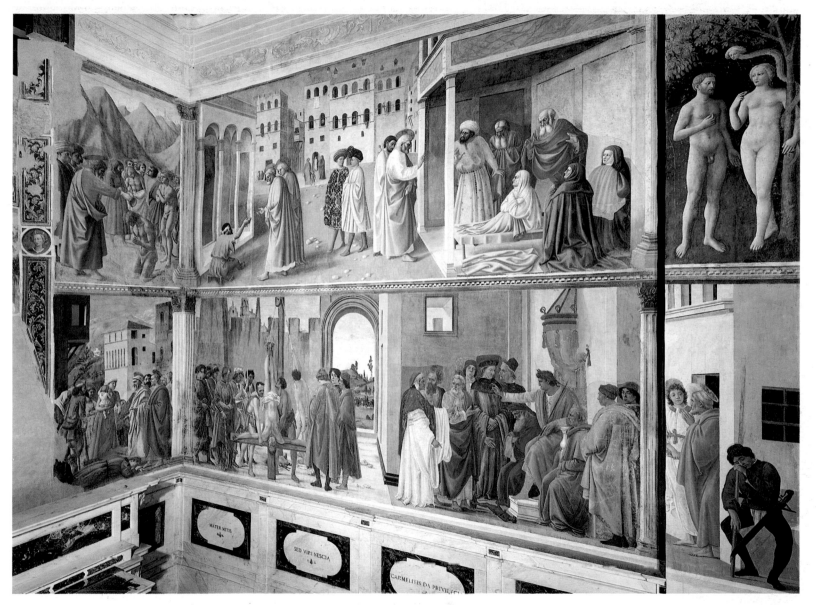

View of the right side of the Brancacci Chapel as seen from the altar

The Expulsion of Adam and Eve

MASACCIO

(2.14 x .90 m)

The Tribute Money

MASACCIO

(2.47 x 5.97 m)

Saint Peter Preaching

MASOLINO

(2.47 x 1.66 m)

Saint Paul Visiting Saint Peter in Prison

FILIPPINO LIPPI

(2.32 x .89 m)

The Raising of the Son of Theophilus and Saint Peter Enthroned as First Bishop of Antioch

MASACCIO AND FILIPPINO LIPPI

(2.32 x 5.97 m)

Saint Peter Healing with His Shadow

MASACCIO

(2.32 x 1.62 m)

Plan of the left side of the Brancacci Chapel as seen from the altar

Saint Peter Baptizing the Neophytes

MASACCIO
(2.47 x 1.72 m)

Saint Peter Healing a Cripple and the Raising of Tabitha

MASOLINO
(2.47 x 5.88 m)

The Temptation of Adam and Eve

MASOLINO
(2.14 x .89 m)

Saint Peter Distributing Alms and the Death of Ananias

MASACCIO
(2.32 x 1.57 m)

The Crucifixion of Saint Peter and Saint Peter Disputing with Simon Magus

FILIPPINO LIPPI
(2.32 x 5.88 m)

The Liberation of Saint Peter from Prison

FILIPPINO LIPPI
(2.32 x .89 m)

Plan of the right side of the Brancacci Chapel as seen from the altar

The Brancacci Chapel, Florence

Queen: "If it be,
Why seems it so particular with thee?"
Hamlet: "Seems, madam! Nay, it is;
I know not 'seems.'"
—*Hamlet*, I. ii

The Brancacci Chapel is a monument history will not let us forget but fate will not let us see—not, at least, as its makers intended. Yet, the time-battered murals that line its walls still constitute one of the most stirring and influential series of images in the history of art. They are concerned with the nature of earthly existence but also with the laws of human vision, for their content is indissoluble from their form and their technique. From our now-distant vantage point in the fast-approaching twenty-first century, we can see that they not only defined the character and form of Italian Renaissance painting at its point of origin in fifteenth-century Florence, but helped to set the long course of Western art until the late nineteenth century. In so doing, they established artistic and philosophical principles that remain clear, that hold fast despite the veil of time, that continue to haunt our imagination to this day.

Their position, as writers of the Renaissance were quick to recognize, is due in large part to the singular talent of one man: Tommaso di Ser Giovanni, known, probably with affection, by the untranslatable nickname "Masaccio," or "Big Ugly Tom" (December 21, 1401–1428), who was born on the feast of Saint Thomas in the rural village of Castel San Giovanni not far from Florence in the Valdarno. What was exceptional about the outlook and work of this painter, who was never

anything but young? To writers of his own century the answer lay above all in his faithfulness to the truths of vision. As the Florentine humanist Alamanno Rinuccini put it: "in painting [Masaccio] expressed the likenesses of all natural things in such a way that we seem to see with our eyes not the images of things but the things themselves." For Cristoforo Landino, who was more specific, he was "a very good imitator of nature, with great and comprehensive relief, and a good designer and pure, with ornament, because he devoted himself only to imitation of the truth and to the relief of his figures. He was certainly as good and skilled in perspective as anyone else at that time, and of great ease in working, being very young, as he died at the age of 26." By the mid-sixteenth century, when Giorgio Vasari wrote his famous and influential biographies of artists, Masaccio had already acquired something of the status of a holy figure among painters, and the Brancacci Chapel had become his shrine. The painter from the wilderness was the revered prophet of a new art, foreshadowed by Giotto, fulfilled by Michelangelo. According to Vasari, "all the most celebrated sculptors and painters who lived from his day to our own"—including Leonardo da Vinci, Raphael, "who owed to this chapel the beginning of his beautiful manner," and "the most divine" Michelangelo—"have become excellent and famous by exercising themselves and studying in this chapel."

Unfortunately, our eyes will never see what those painters saw. The project did not have an easy history from the start. Although decoration of the chapel was begun in the 1420s by Masaccio and by his colleague and sometime collaborator Tommaso di Cristofano Fini (c. 1400?–1440/7), known—as if to distinguish him from his friend—by the diminutive "Masolino," or "Tommy," it was left unfinished for more than fifty years until completed by Filippino Lippi (c. 1457/8–1504). Since the fifteenth century, the murals of the Brancacci Chapel have endured not only the centuries' silent gnawing but also more than their share of accidents and misbegotten attention, so to appreciate their aesthetic character as well as their intellectual content it is essential to keep in mind that what we see of them is damaged and imperfect. Doubtless already darkened by Vasari's time—in 1516 lamps in the chapel were burning half a barrel of oil every day!— the murals were periodically but never more than temporarily revived in every century since their creation with water, varnish, or repaint. As if that were not enough, they also fell prey to changing taste and to the ambitions of later patrons. Escaping one owner's desire in 1680 for something more up-to-date than "those ugly characters dressed in long robes and cloaks in the manner of the antique," they were less fortunate during the century of the Enlightenment. Between 1746 and 1748 the vault, by then apparently damaged by dampness, was replaced with a new one, an operation that not only entailed altering the window but that also caused the loss of the murals on the upper walls of the chapel, by then judged as having "no worth." But worst of all was a fire that 222 years ago in late January 1771 devastated most of the church. Although the chapel and

what remained of its murals narrowly escaped, they were irremediably altered and so, in a strict sense, lost. The fire, besides causing sections of plaster to fall and submerging the whole painted surface of the chapel under a layer of black soot, darkened unalterably and forever those colors whose chemical content included iron by subjecting the pigments on the wall to a melting heat. It also resulted in a long series of well-meaning but generally obscuring restorations.

The paintings that artists of the Renaissance held in such reverence are hardly intact, but a conservation campaign completed in 1988 has freed the murals of the accumulated repaint, smoke, varnish, and dirt of centuries. In addition to the irregularities of some distorted colors and more than a few areas of loss, we have to admit that surface details are mostly worn away. The generally more unified impression is gone with the repaint, and the soft transitions that Vasari praised have now become more abrupt. But the result is not entirely negative. In the bargain Filippino's minuteness is better appreciated, and Masolino's colors have acquired exceptional freshness and delicacy. And Masaccio's colors, once so dark and limited in range, now appear more luminous and more consistent with those of Masolino and his contemporaries, so that he seems less the grand "mutation" some have regarded him. Although the surfaces are pocked, scratched, and worn and although the forms and colors are sometimes raw, sharp, and in some places even flat, on the whole the murals are nonetheless more legible today than at any time since the eighteenth century. It is perhaps a measure of their greatness that, even with their wounds more frankly exposed than ever before, they still communicate so vividly their vision of an ennobled, active humanity and its place in a mutable natural world.

Founded in 1366/7 by Piero di Piuvichese Brancacci and originally dedicated to Saint Peter, the chapel that stands in the right transept of the conventual church of Santa Maria del Carmine was evidently completed by the late 1380s as the burial place for the Florentine branch of the prosperous family of silk merchants. Who actually commissioned the original mural decorations is a question unanswered by surviving evidence, but the undocumented paintings produced in the 1420s, perhaps from as early as 1424 until 1428, by Masaccio and Masolino, were undertaken during a period when Felice di Michele Brancacci exercised legal control of the chapel. Unfortunately for the latter, he never saw the decoration of his family chapel completed. By 1428 Masolino had quit Florence, and Masaccio, having left the project unfinished, was dead. In 1432 Felice himself, who had opposed the ascendant Medici party, was branded a traitor of the state and expelled, never to see home again. The project, thus broken, was only completed in the mid-1480s by Filippino Lippi, whose father, Filippo, had been a member of the convent during the 1420s and, as an aspiring painter himself, had surely watched, if not helped, Masaccio and Masolino.

Thanks to the account left by Vasari and to the evidence of two sinopie recently recovered on the window wall, as well as the existing murals, we can go far

toward reconstructing the iconographic scheme of the chapel. Drawn from the Gospel of Matthew, from the Acts of the Apostles, and from *The Golden Legend*, Jacobus de Voragine's influential thirteenth-century compendium of saintly lore, it presents the most extensive, though not the only, surviving Petrine cycle produced in Florence.

On the very simplest level, the images compose a biography. The cycle, in its original form, traced the life of Saint Peter, beginning not with his actual birth but with his spiritual birth, that is, when already as an adult he first became Christ's disciple. Hence, Peter is always shown as an older man with gray hair and a short, gray beard. This first episode, when Christ, having seen Peter the fisherman at work in his nets with his brother Andrew then called him to become a fisher of men, once appeared in a now lost lunette on the left side of the Brancacci Chapel. It appeared opposite another scene from the saint's discipleship, that is, the episode when, following Christ, he walked on water but, becoming frightened, he started to sink, so that Christ had to save him. Both of these episodes indicate Peter's singular role among Christ's disciples, and he was singled out at other times also. On the occasion when Christ and the disciples were asked to pay a tax but, being penniless, could not, it was through Peter that Christ performed the miracle whereby Peter found money for the tax in the mouth of a fish. This episode is depicted on the middle register on the left wall of the chapel. At the time of Christ's arrest before His death, Peter, otherwise so loyal, was frightened of also being arrested and, as Christ foretold, three times denied knowing his teacher, acts of cowardice that later filled him with remorse. A scene once on the upper left of the window wall and now known through a recently discovered sinopia shows Peter weeping in penitence after his denials. After the Crucifixion, Peter was singled out again. Moments before the resurrected Christ ascended into heaven, He appeared to the apostles and instructed Peter to take care of His followers. Speaking figuratively, Christ said to Peter, "Feed my sheep, feed my lambs," and this episode, known through a sinopia, appeared on the upper right of the window wall. The rest of the cycle is devoted to Peter's ministry during the difficult early days when Christians were being persecuted and doubted. During this period Peter preached, baptized, and healed: he preached at Jerusalem and baptized 3,000; he healed a cripple before the temple in Jerusalem; he raised a dead woman in Joppa; he even healed the maimed with his shadow. He also possessed the power to strike down. Thus, on one occasion, when a man named Ananias tried to cheat Peter and the church by not contributing his share, he fell dead at Peter's mere word. Peter contributed to the establishment of the church, and he was named first bishop of Antioch, where he had been imprisoned for a time by the local king, Theophilus, but where he converted both the king and the city by ressurecting the

king's dead son. Peter's enthronement as first bishop of Antioch, depicted on the lower register on the left wall of the Brancacci Chapel, also marked the beginning of the official church, not only in that city, but also later in Rome. In Rome, the setting for the large scene on the right wall, Peter contended with persecution and sin in the form of the Emperor Nero, who was under the influence of a charlatan named Simon Magus. Although Peter consistently refuted and exposed Simon, Nero still had the apostle locked up and eventually crucified.

Because the narrative program of the chapel illustrates in a detailed way the exemplary life of Saint Peter, the images can be read according to the order of events in the saint's biography, but because they are put within the context of the story of Adam and Eve—whose importance to the whole is paramount—and the larger theme of salvation, the cycle also demands to be read without regard to narrative or chronological sequence. Over and again, we are invited to make connections across time, to consider ideas suggested by visual analogies and contrasts, not only within a single scene itself, but also from one scene to another adjacent, opposite, or even diagonally across from it on another wall. Who did what, particularly in the sections painted by Masaccio and Masolino, is still a debated question that goes to the heart of their relationship and their artistic identities, but the cycle nevertheless presents a remarkably coherent and carefully conceived thematic whole. At least in what survives of it, there is no argument about one thing: Masaccio was the dominant creative force in the Brancacci Chapel, a force so powerful as to influence Masolino from the scaffolding and Filippino from the grave. It was Masaccio to whom artists and writers of the Renaissance responded, and it was Masaccio, not Masolino, who became a prophet in the Vasarian epic of man's salvation of art.

Like Giotto before him, Masaccio—"Giotto born again," as Bernard Berenson aptly reincarnated him—sought to present a human drama enacted by substantial and familiar beings moving on a carefully controlled stage, and also like his great predecessor, he sought to make his narrative clear and accessible. But if he shared some of his ancestor's aims, he also shared those of his contemporaries, the sculptor Donatello, the architect Filippo Brunelleschi, and the architect-theorist Leon Battista Alberti, and so compared to Giotto, Masaccio's art gains greater vivacity and immediacy by means of its more rigorously optical and, therefore, more sentient and analytical description of the features of man and the natural world. In a way unprecedented in Italian art, Masaccio orchestrated the elements of nature—light, shadow, atmosphere, and space—and the elements of art into a seemingly casual but complex and measured visual symphony, one in which all the various interrelated parts compose a perfectly unified whole, one that more than ever before involves those who look at it.

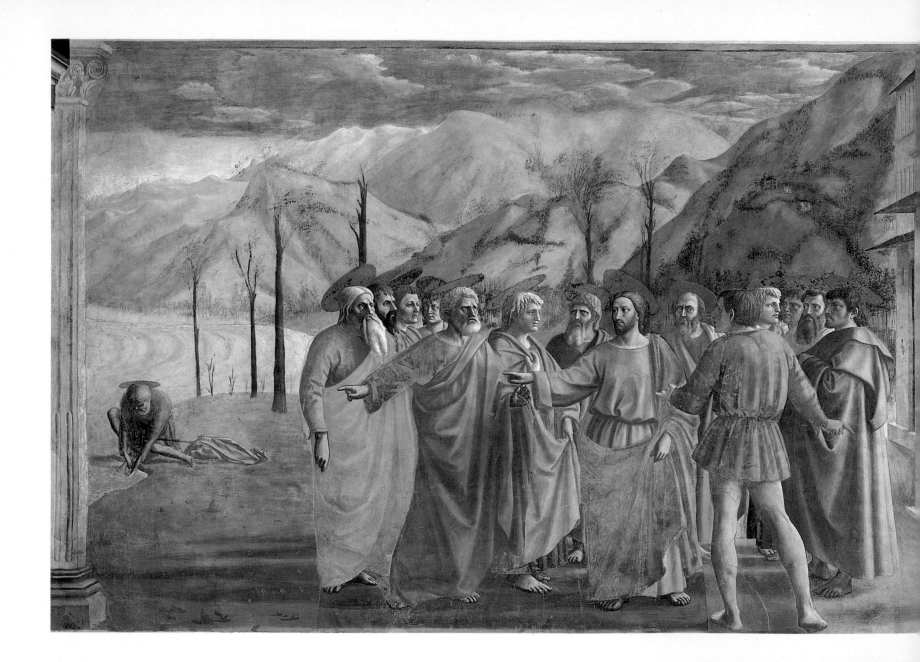

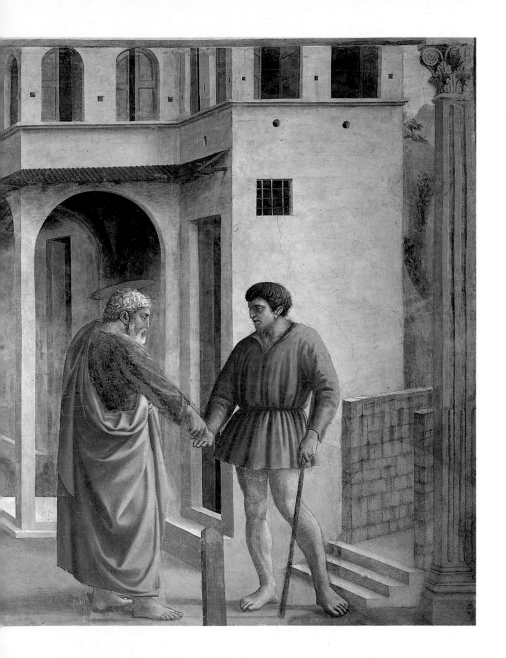

MASACCIO
The Tribute Money

This image, the most important in the chapel, is told only in the gospel of the former tax collector Matthew (17:24–27). It is set in the lakeside city of Capernaum, where Christ and His apostles were approached by a local tax collector exacting the temple tax.

 Christ, wearing a bright blue cloak at the center, dominates the action and the composition. He stands between the tax collector, whose back is turned to the viewer and who sticks out his hand for the money, and the bearded figure of Saint Peter, clad in the more muted yellow-orange cloak, who reacts with anger to this demand. But Christ intervenes and instructs Peter to cast a line in the lake, pull out the first fish that bites, and find a coin in its open mouth. This Peter does, finding the coin in the distance at the left and paying the tax collector at the right.

Nowhere is Masaccio's genius more profoundly evident than in the *Tribute Money*, perhaps the most important painting in a city of fabled creations. Not only does it exemplify the aims of the Early Renaissance as a whole but of Masaccio's art in particular. At the same time, it sums up and sets forth the major theme of the chapel, the saga of human salvation as seen through the prism of Saint Peter's life.

> *When they came to Capernaum, the collectors of the half-shekel tax went up to Peter and said, "Does not your teacher pay the tax?" He said, "Yes." And when he came home, Jesus spoke to him first, saying, "What do you think, Simon? From whom do kings of the earth take toll or tribute? From their sons or from others?" And when he said, "From others," Jesus said to him, "Then the sons are free. However, not to give offense to them, go to the sea and cast a hook, and take the first fish that comes up, and when you open its mouth you will find a shekel; take that and give it to them for me and for yourself.*

Historians have gone out of their way to point out the ostensible triviality of this episode and its rarity in art, but perhaps precisely because of that Masaccio felt free to alter the text and to recast the story in a way that sharpens its dramatic character. Rather than a sequence of conversations, moments, and settings almost innocuous in their civility, he constructed a single triangular and dangerously incendiary confrontation. We are drawn immediately into the center of it by a brilliant flash of warring colors. One lone representative of local authority, his intense vermilion clothing fiery and aggressive beside the Savior's deep blue, stands like an unexpected obstruction before the group. Mouth open in speech, he sticks out an importunate hand palm up for money and, as if this were not enough, at the same time—or so it seems—comes close to prodding Christ in the chest. At this, Peter, his face knotted and mouth twisted with a ferocious emotion that seems all the more pugnacious beside John the Evangelist's placid profile, raises a paw-like hand as if to answer in kind. Belying the meaning of his name, he leans forward on a body now become an ungainly, teetering, seemingly three-legged thing. His is an instinctive reaction, possibly reckless but one that according to the Bible and other sources would not be out of character: Voragine, following Saint Augustine, said that had the saint found out Judas' plot, "he would have torn the traitor to pieces with his teeth"; and, of course, on the night of Christ's eventual arrest Peter's violent temper did lead to bloodshed, when after taking a knife he slashed off the ear of the high priest's assistant. We are thus aware of potential danger, and the pressure of the moment is made all the more intense by the constricting circle of apostles who focus on the center. The confrontation between Peter and the tax collector, worsened by the fact that each thrusts out his left hand, now takes on the uncomfortably sinister air of a showdown. At this moment, Peter, though a disciple of peace, seems little better than the other, for in confronting him he actually resembles him. The pair are, in fact, not only antagonists but also analogues, whose likeness is suggested by their equally expansive movement in opposing directions, by their subtly mirrored

detail, the *Tribute Money*

stances and doubtless by the once more ardent yellow of the saint's agitated robe. But stepping between them and looking directly at his most passionate and occasionally errant disciple, Christ serenely points out the solution. Unmistakable and authoritative, His gesture shines brightly above the sparring lefts that hang dissolving in the air.

Masaccio's scene is all too trivially human and vulgar, yet curiously it is presented in a tone whose lofty gravitas makes us wonder if there is perhaps not more in it than first meets the eye. Masaccio, after all, is an artist who encourages us to look closely but also to take the longer view. Just as the small human incident depicted in the center of the *Tribute Money* is the most immediate part of a story played out in the second and final episodes to the left and right, so the story of the *Tribute Money* is part of a larger drama that stretches beyond the narrow chronological limits of the frame and, encompassing the entire wall, unfolds with the story of Adam and Eve on the entrance arch of the chapel to the left. It is a story no less human than the one on the wall beside it.

Although Masaccio's figures are individualized and believable human beings, they are also conceived as types. Masaccio understood that a particular characterization gained strength and vitality depending on those around it. His figures alternate in terms of physical features and luminosity, and he even painted them in alternating fashion. Set beside Peter's craggy face, John the Evangelist's beautiful, golden head becomes a foil. It is a physical contrast that also suggests something of their natures, for the passionate Peter seems all the more pugnacious beside the beloved disciple's sweet mildness. The contrast between Peter and John is repeated in the paired heads of the tax collector, who is the villain of the drama, and an apostle who could be John's twin. As the latter pairing reveals, the play of light and dark, besides its role in defining form and in furthering the drama, also has moral connotations. The tax collector's is not the only dark face, for his profile is seen in relation to the group of apostles to his right, and it is there that Masaccio measures evil and repentance. The blond head to the tax collector's right links him to another figure standing at the back of the group; his head is the only part of his body that we see, and his is the only face shown in the shadow, a clue, as in Leonardo's *Last Supper*, that he is Judas. And what of the magnificent figure at the far right, which so impressed Vasari that he claimed it was Masaccio himself as Saint Thomas? Judas, who will betray Christ for money, is placed halfway between the latter figure and the tax collector, who also seeks money. Could the figure who turns his back on the transaction at the far right perhaps be the former tax collector Matthew, who repented of his former life, who presents a moral antithesis to his unrepentant partners, and whose gospel is the source of this very tale? Closely linking him to the figures of Judas and, above all, to the tax collector, Masaccio endows the apostle with a noble dignity that suggests his virtue and even gives his choice of good over evil a kind of physical proof.

detail, the *Tribute Money*

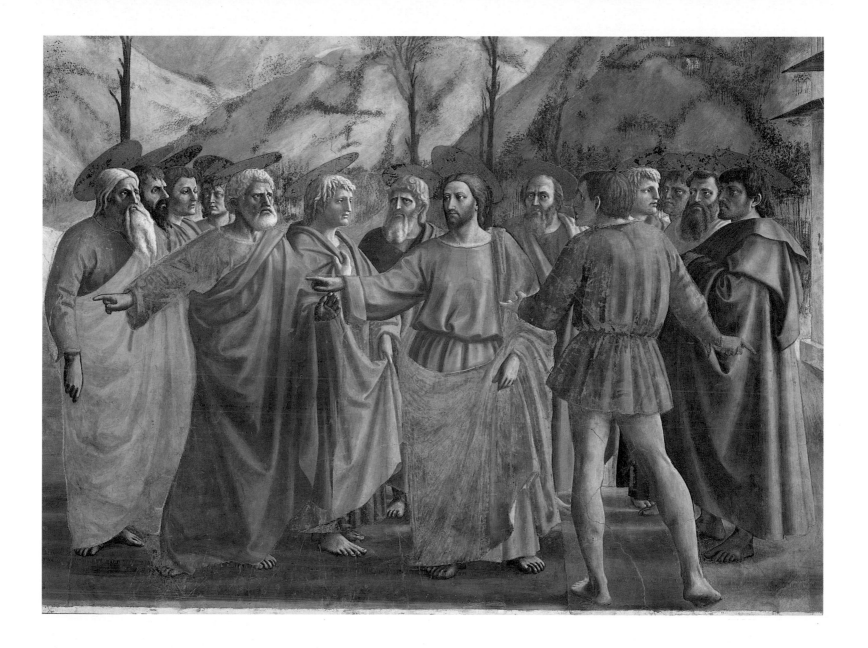

Masaccio
The Expulsion of Adam and Eve

Having disobeyed God's commandment not to eat of the fruit of the tree of the knowledge of good and evil, Adam and Eve are condemned to know toil, pain, and death in the world of the living. The bleak desert that they enter is specifically identified with our space, our world, because the glaring light that gives form to their substantial bodies is the same light that illuminates the chapel. Their connection with us is also felt in the truthfulness of their anatomies, in the naturalness of their movement, and in the strength of their emotion. Although Eve covers herself in a pose reminiscent of classical statues of Venus *pudica*, her unrestrained agony is a world apart from the latter's cool reserve. In Masaccio's remarkable conception the two figures, which convey horror as well as shame, seem to fuse together as if one. The tragic story of the first parents, who seem to walk in the direction of our space, provides the context for the entire cycle, whose larger drama concerns us all: salvation and the hope for eternal life. Thus framed by the story of Adam and Eve, the cycle of the life of Saint Peter becomes the saga of humanity's abiding desire to return to God and the church's role in guiding us past the beguiling temptations and in succoring us from the painful torments of the world.

The two contrasting heads, the one dark the other light, differ in the way they show their emotion. While Adam covers his darkened face and lets out a muffled sob, Eve lifts her head and releases an uncontrollable wail. Shadow dissolves the forms of Adam's face and neck, and light gives Eve's foreshortened profile an alarming shape. The two heads, conceived entirely in terms of light and shade and without a single line, are also painted with astonishing freedom. Masaccio's brush conveys emotion but also the effect of forms blurred by rushing movement. Eve's eyes are but violently applied strokes of dark and hardly describe eyes as we know they are but rather eyes distorted as we might see them under such conditions. The light on Adam's fingers, indicated by paint applied in bold, untidy strokes with a heavily loaded brush, suggests essential form, but Masaccio, who does not trifle with the insignificant, makes little effort to show such things as nails.

30

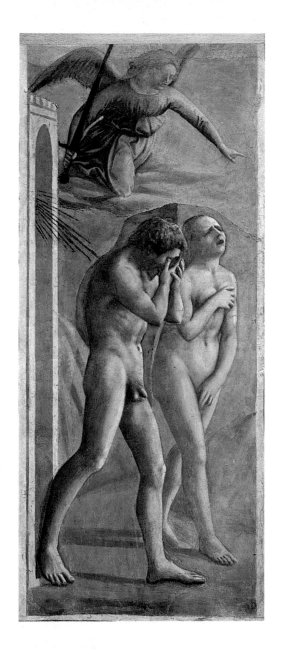
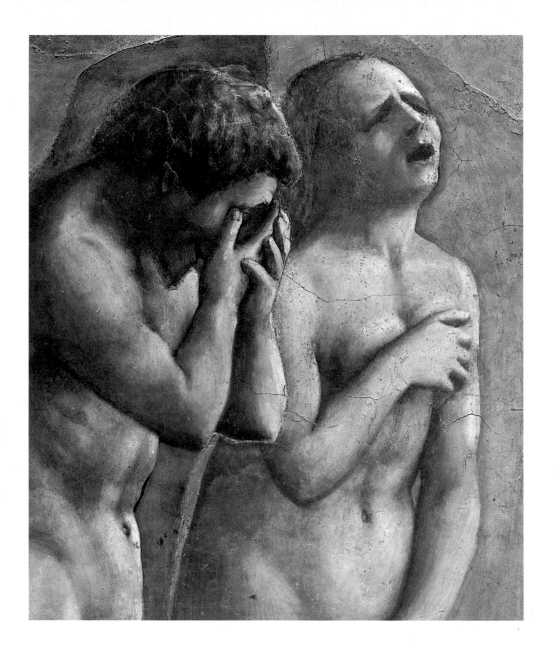

Guilty of disobedience, the two sinners burst into the shocking glare of a pitiless, searing light, so strong it seems to bleach the flesh of Adam's fingers and thigh. At the very instant that this alien world of dust and barren rock opens before them, the protective gate of Paradise seems to narrow and shrink, sealing from human view the lush beauty of the garden and God's face. There only one thing was forbidden them: the fruit of the tree of the knowledge of good and evil. Now, the words of their maker —"the day you eat of it you shall die" (Gen. 2:17)—pursue them with inescapable, penetrating meaning, perhaps already made explicit in the skull-like features of Eve's foreshortened face. Not only the once-golden rays of God's voice but even the avenging angel's glowing red clouds and the shadowed ridges in the landscape beyond, all seem to radiate from the same invisible source and force them on. The fall and rise of the two hills, following legs and cutting through knees, lend abstract force to the cadence of human steps. And still, within the compositional network of boldly crisscrossing rhythms the angel's rigid knee, like a feature out of Giotto's art, adds irresistible pressure to Adam's burdened shoulders. But rather than physical force, it is nothing more or less than the consciousness of guilt that seems to drive them away, for with innocence lost, they now know shame. Although naked and as different in their nakedness as he is dark and she its opposite, both share the same emotion, the same guilt. And seen from the floor below, they even seem to fuse into a single heaving shape, blurred by movement and light: Adam's dark, almost faceless head seems to merge with Eve's, and his arms, sometimes criticized for their awkward proportions, for a moment seem hers too. Not only does his arm overlap hers but his flesh seems to be transparent, for in a kind of optical double entendre light meets shadow on his forearm along a line that suggests the contour of her underlying arm as well. Light and shadow seems to join them shoulder to shoulder, and for a moment another arm almost seems to wrap both of them in its sweeping grasp. They are two hearts in one form, swollen with a common agony, wailing with a single voice.

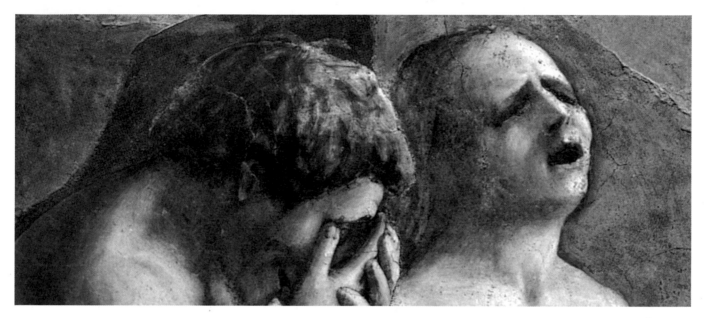

detail, *The Expulsion of Adam and Eve*

The quaking emotion of Adam and Eve's expulsion, so different from the still contentment and dark sensuality of Masolino's phosphorescent *Temptation* on the opposite side of the entrance, follows the thrust of the angel's gesture and, as if giving visual form to Eve's piercing scream, reverberates in the repeating waves, in the curving shore, and even in what remains of a now-leafless, windblown tree behind Christ in the *Tribute Money*. Then, dissipating and diminishing to a pianissimo, it slows and comes to a stop at the place where Peter pays the tax. Beside the fury of the *Expulsion*, the closing episode of the *Tribute* has an air of fixity and somber quiet. His head recalling classical images of Hercules, Peter is very different from the angry, unstable sinner we see in the center or, even more, the ambitiously foreshortened, collapsed form who draws the coin from the mouth of the fish. His passion cooled and now resolute in a way that very much reflects the meaning of his name, he follows the downward thrust of the transaction to its conclusion.

By the same token, as the apostle at last satisfies that unwelcome demand, the official stands relaxed and at rest, his appearance muted by shadow, his pose without strain. Holding a lowered staff and positioned before a walled path, he is the antithesis of the dynamic, airborne, sword-bearing angel who guards the entrance to Paradise.

The contrast between the angel and the tax collector, like the contrast between the two episodes of which they form a part, extends even to technique, for the carefully rendered description of the wooden texture of the post that separates Peter and the tax collector is a world apart from the looseness and freedom with which Masaccio painted the *Expulsion*. Clearly, Masaccio understood the dual properties of light to define form and to define texture, or what Leonardo would later call *lume* and *lustro*, but more than that he also perceived their effect on the viewer, whose eye, like the painter's brush, can be encouraged to dwell on the tightly rendered patterns of one surface or to glide over another. Understanding this, he was able to manipulate the viewer according to the breadth and implicit speed of his brushwork, and in an analogous way he also understood that light and shade could be used to reveal and to hide, in short, to discriminate. Thus, by accentuating and, indeed, animating the movement of the right arm of Peter as he pays off the tax collector while shading, and thus diminishing, the recipient's right arm, Masaccio's light furthers the action but also clarifies it. Such calculated selectivity guides our eyes and, miraculously

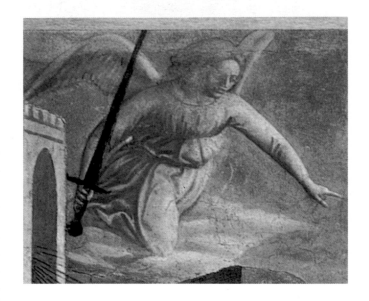

detail, *The Expulsion of Adam and Eve*

implying the passage of time, heightens the suggestion of spontaneous movement. Thus, Masaccio's handling varies from figure to figure, the one softened by shadow, the next picked out by light, and in this sense, the two scenes at the ends of the wall and at the margins of the narrative are extremes. By furthering the dramatic contrast between them, Masaccio brought the unrestrained emotion and explosive movement of the *Expulsion* to an even more decisive and unmistakable pause.

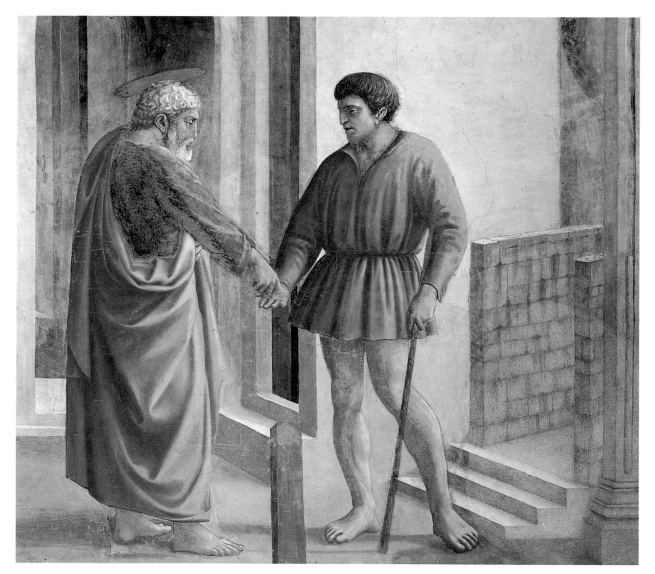

detail, the *Tribute Money*

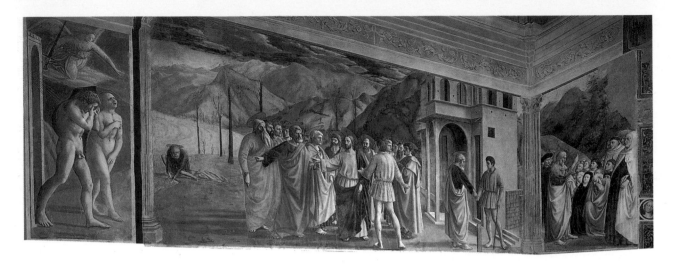

The formal links that Masaccio developed between the story of Adam and Eve and the *Tribute Money* do, in fact, allude to a larger, underlying, thematic connection, one that is suggested by the passage in Matthew (17:22–23) immediately preceding the story of the tribute money: "As they were gathering in Galilee, Jesus said to them, 'The Son of man is to be delivered into the hands of men, and they will kill him, and he will be raised on the third day.'" By means of this juxtaposition in Matthew's text, the story of the providential fish becomes a parable on the Passion, that is, on Christ's death and resurrection from the tomb. Like the tribute, which Christ paid even though as son of the greatest king He need not have, the Passion was an act of awesome humility, for only by debasing Himself and taking the form of His creature, a lowly thing made of dust, could the Lord redeem humanity from the curse of Adam and Eve and reverse its downward fall. The tribute that Peter delivers into the hand of the collector is thus an allusion to God's merciful, loving gift of His only son. With that death He repaid the debt "for

me and for yourself" and, canceling the error of Original Sin, thereby reopened the way back to eternal life in the garden. God's abiding mercy is perhaps apparent in the *Expulsion*, where the angel's poignantly sympathetic expression suggests the presence and assurance of divine love even at this terrible moment of retribution. It is precisely such love that stands in direct contrast to the hatred of Christ's punishment at human hands.

In light of the larger meaning of the *Tribute Money*, the prominent but generally ignored post that is so carefully positioned and forcefully projected between Peter and the tax collector is perhaps no more casual than the story itself. It is, after all, the object closest to us in the image and, indeed, on the entire wall. So close to us is it that the frame below cuts it off, preventing us from seeing where it enters the ground. It may well be that it is, so to speak, grounded in contemporary life.[1] Curiously the post in the *Tribute Money* is so near as to seem unfixed in space, but that is perhaps the point: it pops up out of nowhere, mysteriously and without explanation,

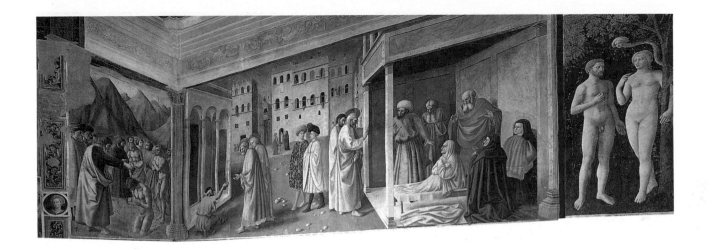

very much like the providential fish that emerges from the lake. Moreover, the only other props in this spartan drama are two, both of wood: Peter's fishing rod and the tax collector's staff. Are these wooden poles perhaps allusions to the Crucifixion as well, for what was the cross if not the instrument by which God rescued humanity and at the same time the instrument by which the laws of human society exacted their painful price?

However central an event the Passion is in Christian history, it is encompassed by something larger. This wider drama, which includes the *Expulsion*, is not only essential to the Christian scheme of history but, most remarkable of all, to Masaccio's vision in the Brancacci Chapel as well. Indeed, if we cannot understand the *Tribute Money* without reference to the *Expulsion*, we cannot fully understand either without reference to the *Temptation*. It might seem odd to place the *Expulsion of Adam and Eve* on the left side of the entrance, since their temptation by the serpent, depicted by Masolino in

a corresponding position across from it, comes first in the Biblical narrative, yet the *Expulsion* is not only a conclusion but also a beginning, for it marks the start of humanity's earthly journey and at the same time alludes to its end. Beginning with the Old Testament and continuing to fulfillment, though not completion, in the New, the dark saga of man's exile and pilgrimage in this world only ends with the end of history itself at the moment of final judgment. If Adam and Eve's banishment from Paradise and entry into the temporal and spatial continuum of the world marks the beginning of earthly history and Christ's Passion its middle, then the Last Judgment, when time and space dissolve, defines its end. But the Christian view of history is not only providential but also circular. Thus, framing and encompassing human existence in the world and in time is another, higher existence beyond earthly time and space: eternal life in the garden, whose sublime happiness we knew before the Fall and perhaps, after Judgment Day, may know again.

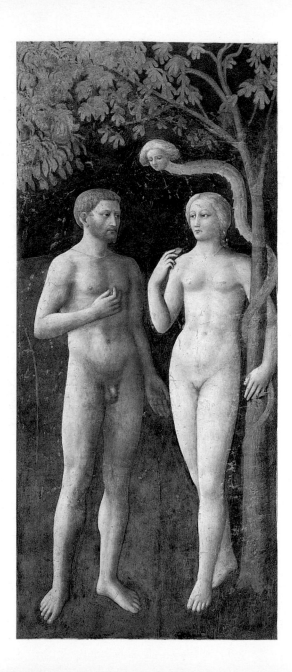

MASOLINO
The Temptation of Adam and Eve

The story of the first husband, the first wife, and the fateful fruit is taken from the story of Creation related in Genesis. Flirting with danger and mimicking the serpent, Eve wraps her long arm around the deadly tree, whose leaves are those of a fig. In fact, she has already disobeyed, for God warned them not even to touch it. Induced by the soft blandishments of the lovely-featured serpent, the two innocents now hold in their fingers morsels of fruit, which the woman, all the while staring at the man, begins to bring to her lips.

That state of self-sufficient oneness with God is the goal toward which humanity aims, and its conditions, which we see in the figures of Adam and Eve in Masolino's *Temptation*, are fundamental in understanding Masaccio's conception of the world outside Paradise, for he conceives of the earthly world of time and space that Adam and Eve encountered beyond the heavenly gate as antithetical to the one they left behind. When Eve tells the serpent that God has forbidden them from eating the fruit of the fateful tree, that beguiling creature persuades her otherwise:

> *"You will not die. For God knows that when you eat of it your eyes will be opened, and you will be like God, knowing good and evil." So when the woman saw that the tree was good for food, and that it was a delight to the eyes, and that the tree was to be desired to make one wise, she took of its fruit and ate; and she also gave some to her husband, and he ate.*
> (Gen. 3 :4–7)

Later, Adam and Eve pass from the nocturnal darkness of the *Temptation*, where they are shown with their eyes wide and bright, into the intense light beyond the gate in the *Expulsion*. Their shame is evident along with their guilt, and so they cover themselves, but there is something more, and it is this that is truly remarkable about Masaccio's interpretation: having

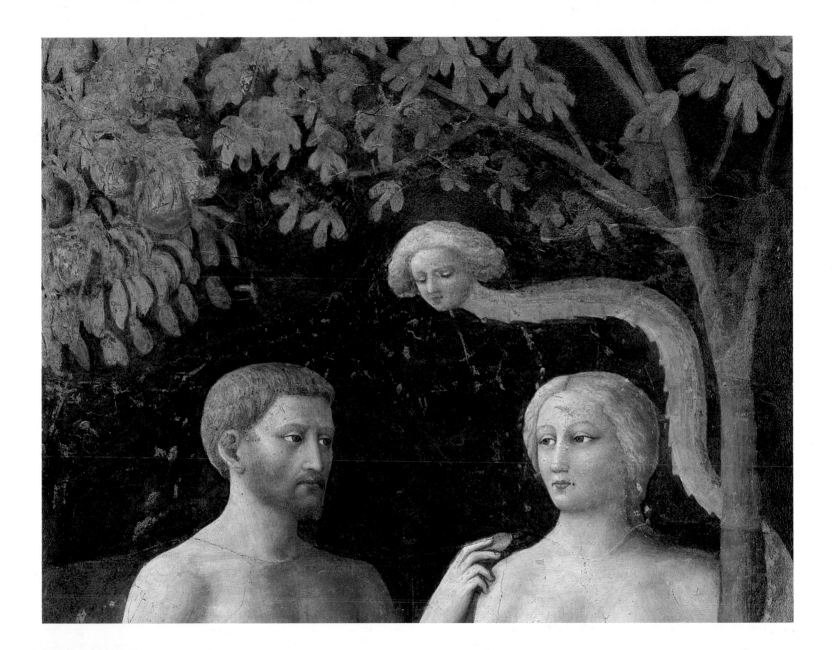

opened their eyes to knowledge, they awaken to discover that they are blinded by it. Adam does not merely hide his face but touches his darkened sockets, and Eve lifts up her head to reveal deep gray gashes, where before we saw hazel spheres set in sparkling whites: as well as guilt, the horror of their emotion is also the hysteria of sudden and crippling blindness.

Whereas Masolino's *Temptation*, with its unusual black background, is identified with the certainty of wide-eyed innocence in the dark, Masaccio's *Expulsion* is thus identified with blinding knowledge in the full light of day. But how can this be? Adam and Eve enter the world of natural forms, natural space, and natural light, in short, our world, for the gate of Paradise in the *Expulsion* is identified with the actual entrance to the chapel and the fictive light of the murals is identified with the actual light of the window on the altar wall, both coming from the right side. In both the *Expulsion* and in the *Tribute Money*, Masaccio captured the visual reality of earth and wind, of sunlight and shadows, of recognizable shapes and human emotions: the experiential world of the senses. He painted according to the truths of human vision and counterfeited the world we see with our eyes, but in his extraordinary scheme the tangible reality of earthly vision has become a symbol of ignorance and deception, all the more compelling because it fools us too. Light is still identified with truth, but just as there are two lights, both earthly and divine, there are two truths: the truth of this world—what by the logic of natural laws we perceive visually—and that of heaven—what we cannot see but know by faith. But unlike the abiding reality of heaven, that of the world is fleeting, paradoxical, and false. To our everlasting trouble we live in a realm of illusion and mistaken appearances, where things seem to grow and shrink, take shape and dissolve, disappear into the distance, or, like the post in the *Tribute Money*, appear unexpectedly in front of our eyes. It is certainly true, as Cristoforo Landino said, "nothing is visible without light," but as Masaccio also reminds us, the same light that reveals space, form, and texture can also blur and obscure. And so, in leaving the unchanging spiritual reality and true light of God's sight, Adam and Eve entered the false light and false beauty of the changing world of matter, where what is true and false, like good and evil, is not so easy to discern. This, alas, is our world, a bewitching but constantly shifting, mutable place, a benighted place where nothing remains what it seems, a place of enchanting illusion, where images projected on a flat surface can even pretend to dissolve the solid wall behind them. In the end, our ancestors discover that the knowledge they sought is really no knowledge at all but only the curse of confusion, uncertainty, and doubt.

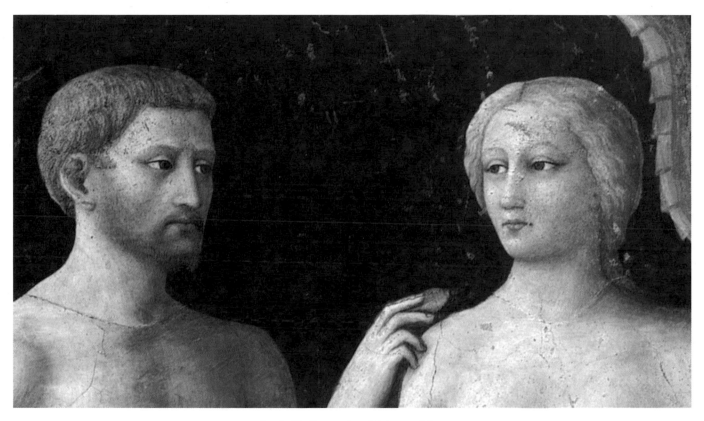

detail, *The Temptation of Adam and Eve*

The illusory nature of earthly truth extends further. It relates, ultimately, to the very structure of Masaccio's work in the upper register of the Brancacci Chapel. In the *Tribute Money* we will recall, Masaccio presents us with a paradox within a paradox: a scene that seems trivial but is not, set in a world that seems concrete but is not. In parallel fashion, both the form of nature and the form of the narrative point to something more, something that lies beneath the immediate surface. This is not merely a paradox but a mystery. It is, however, a logical mystery, and to convey the rationality of God's plan Masaccio constructed both his design and his narrative in terms of simple mathematical relationships based on a module. In its thinking his system is remarkably like the modular architecture of his friend Brunelleschi, and while lacking the exactitude of architecture, it is apprehensible with the naked eye and allows us to take the real measure of the story.

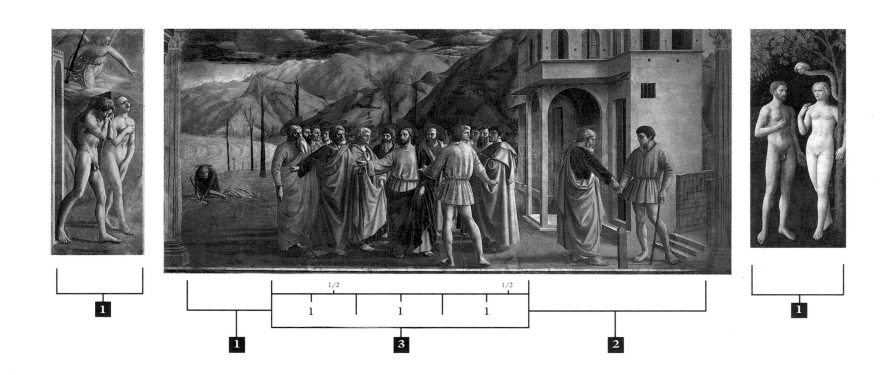

The width of the *Tribute Money* is six times that of the *Expulsion*, so the relationship between the two paintings is approximately six to one. The three episodes of the *Tribute Money* in turn divide in terms of the same module: one for the episode of the fish, two for the payoff, and three for the central confrontation, listed here according to the relative importance of the overall story. Indeed Masaccio places this central confrontation, a seemingly insignificant moment within the larger drama of Salvation, at the center of the entire wall: the *Expulsion* and the episode of the fish together comprise two modules, the central scene comprises three, and the final episode two: two to three to two. We are reminded that ratio, or proportion, derives from the Latin word for "to think" or "to mean."

Although the action in the *Tribute Money* has the air of a casual encounter, Masaccio applied his system of modular design even to his figures and thereby gave a mathematical dimension to the naturally interconnecting human relationships that otherwise seem based on spontaneous emotion. As already noted, the central group amounts to three modules; within it, the distance from Peter's extended right foot to the extended right foot of his antagonist, the tax collector, equals two, with the result that the remaining figures enframe the three principal characters: one-half to two to one-half. Further, the three modules of the central group also divide into those including Peter and Christ (the left and center modules) and that headed by the tax collector (the right module). Finally, the larger of the two sections even subdivides in half, significantly at the juncture of the hands of Peter and Christ. The system, which also considers seemingly minor elements such as the trees in the background, the tax collector's staff, and the post, involves both the composition and the human drama in a clear, simple, and unified whole that is also a complex of significantly interrelated parts. Form and content are inseparable, and underlying this trivial story is the incontrovertible logic of mathematics.

In arranging the fourteen figures at the center of his *Tribute Money*, Masaccio sought to preserve the unity of the action while heightening the reality of the drama. He relied upon numerical and, since his figures stand in a spatial grid, even geometrical arrangements. The overwhelming impression is of a single integer or perfect form, but within that unit other figures animate it. Rather than being fixed, these secondary arrangements are overlapping and shift, depending upon how we weigh the action or survey the actors. The central group is often rightly compared to a circle or an ellipse, but it is also a denser, more complex, irregular, and elastic thing. It is both a complex compound as well as a single atom: several interwoven geometrical forms encompassed within the dominant impression of a circle. It has the intimacy of a frieze, the animation of a figure eight, the inclusiveness of a horseshoe, as well as

the unity and perfection of a circle. Christ is the crux, pivot, linchpin, and hub of it all. The simple clarity and perfection of the whole, doubtless reinforced by the fact that the central axis of the entire wall occurs precisely where Christ applies the weight of his right foot, has a numerical proof as well. The cast shadows help arrange the figures in ranks in depth: the tax collector is first, then Christ and Peter in the second file, then Andrew, John, and the apostle on the far right, and then the rest. In the abstract language of numbers the sequence is: one, two, three, and then the rest.

But Masaccio also divided the group in a way that emphasizes both its symmetry and its symbolic content. He encourages us to see Peter and his foil, John the Evangelist, as a pair, just as he shows John's twin seemingly sewn, Janus-like, to the tax collector's head. He also detached Christ by framing his luminous, animated head between two impassive graybeards, a clustering that is significantly accented by three trees directly behind them. The whole group is then completed by the figures, functioning like great parentheses, four on the left, three on the right, at either end. The action moves from the center out, but somehow it then returns to Christ, as if in answer to some arithmetic imperative: the few, the two, the one in three. And so the group, like a perfectly balanced equation, multiplies and divides, but also like a living organism, expands and contracts from and to its heart. The incident between Peter and the tax collector, the story of the tribute money, and, by implication, the drama of Salvation incorporating both the narrative and form of the *Temptation* and the *Expulsion* come full circle to rest in Christ, alpha and omega, the one in whom it all began.

Masaccio's image points to the profound truth that lies beyond the banalities of this world. Surely it is no coincidence that this story, which is so much about numbers, has as its central subject the ultimate symbol of material wealth: money. What, we are asked, is the value of earthly riches beside eternal life, for the gleam of gold is as false as the beauty of the fruit of the deadly tree of Paradise. The numbers of this world do not add up, whereas those of the divine plan are finite, clear, and perfect. By means of the supremely rational mathematical structure that underlies his image and that conveys the elemental certainty and rightness of God's plan, Masaccio, like Brunelleschi in his architecture, gave proof to Giannozzo Manetti's assertion that the mysteries of the Christian religion are as logical as the axioms of mathematics, but by juxtaposing this notion in a tellingly antithetical way with the emblem of earthly wealth, he gave it a more piquant and profound immediacy and concreteness.

Masaccio's habitual use of antithesis points to a way of thinking that is fundamentally dramatic. This cast of mind runs so deep as to govern both the form and content of the rest of the painter's work in the chapel, and its dominance is such that it even appears to shape the work of his collaborator, Masolino.

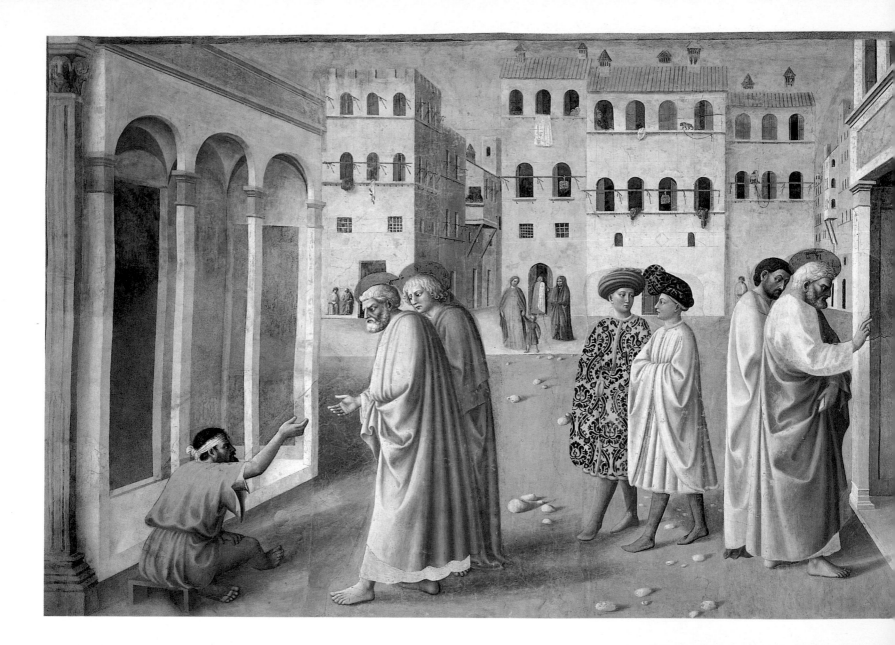

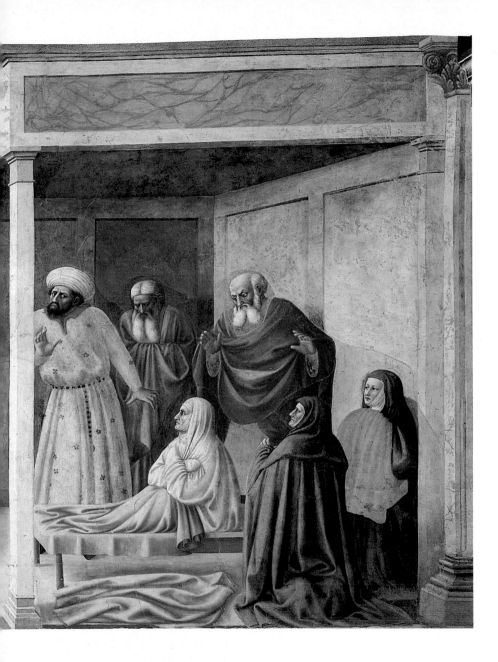

MASOLINO
Saint Peter Healing a Cripple
and the Raising of Tabitha

This scene, set in a town, depicts two episodes that took place in Jerusalem and in Joppa; therefore, Saint Peter is shown twice. On the far left, wearing golden robes and accompanied by the blond-haired Saint John the Evangelist, Peter heals a man crippled from birth who begged for alms in front of the entrance to the temple in Jerusalem. According to the story recounted in Acts (3:1–10):

> *Peter fixed his gaze on the man; so did John. "Look at us!" Peter said. The cripple gave them his whole attention, hoping to get something. Then Peter said: "I have neither silver nor gold, but what I have I give you. In the name of Jesus Christ of Nazareth, walk!" Then Peter took him by the right hand and pulled him up.*

In the unrelated episode on the right, Peter, accompanied by an unidentified figure, raises from the dead a pious woman who had died in Joppa. According to the story, the apostle was met by widows, here dressed in black, who showed him the many garments, one of which lies by the bier, that the woman had made when still alive:

> *Peter first made everyone go outside; then he knelt down and prayed. Turning to the dead body, he said, "Tabitha, stand up." She opened her eyes, then looked at Peter and sat up. He gave her his hand and helped her to her feet. The next thing he did was to call in those who were believers and the widows to show them that she was still alive.* (Acts 9:36–41)

47

Indeed if we consider the *Tribute Money* in relation to Masolino's *Saint Peter Healing a Cripple and the Raising of Tabitha*, its themes as well as its style take on sharper relief. The two scenes are in many ways antithetical. Whereas the *Tribute Money* is set in sight of the country, Masolino's scene takes place in a town. Whereas in the *Tribute Money* the landscape forms a great descending arc into which the light enters in a strictly horizontal direction, Masolino's image has an enclosed feeling into which shadows fan out from the cripple in the lower left-hand corner. But beyond this, the two scenes answer each other and set each other off. Masolino's setting, which elaborates the perspectival system suggested by Masaccio's building in the *Tribute Money*, is perhaps the most engaging urban view since the early fourteenth century and Ambrogio Lorenzetti's *Effects of Good Government in the City* in the town hall of Siena. And perhaps Vasari had this scene in mind when he rightly praised the "softness and harmony" of Masolino's colors in the Brancacci Chapel. It is a beguiling work, and one in which Masolino declares himself to be no less skilled than his partner in the tricky technique of true fresco. As if divided by a street, the foreground opens to a vista of a wide square, paved only in the distance and parting at intersections to reveal glimpses down cross streets lined with delightfully colored buildings, each one slightly different in height,

color, and design. From windows equipped with the iron hardware known as *erri*, we see further proof of the city's wonderful variety and richness: gossiping neighbors, bird cages, potted plants, cloth hanging over a sill here and there, even so exotic a creature as a tethered monkey poised on the ledge of another. Down below, a conversing couple sits on a bench, a young mother leads a barefoot child by the hand, and others go about their business. This seems hardly the setting for pain, sickness, and death. Indeed, its infectious delight in description and relish for ornament contrast with the spareness of Masaccio's *Tribute Money* on the opposite wall. To contemporaries Masolino's view must have reflected—far more than any other Florentine work we know around this date—life outside the door of the Carmine itself. It is painted with just enough veracity to blur the line between the fictive world of the narrative and the recollected experience of the viewer, but as it approaches the natural world, it also detaches itself from its textual source. According to the unrelated accounts in the Acts of the Apostles, the events depicted here took place in two separate cities: Jerusalem and Joppa. How familiar would most fifteenth-century viewers have been with the not immediately obvious details of these stories, which are not identified by inscriptions as in some painted cycles? Perhaps not much more than many people today. But perhaps the names

detail, *Saint Peter Healing a Cripple and the Raising of Tabitha*

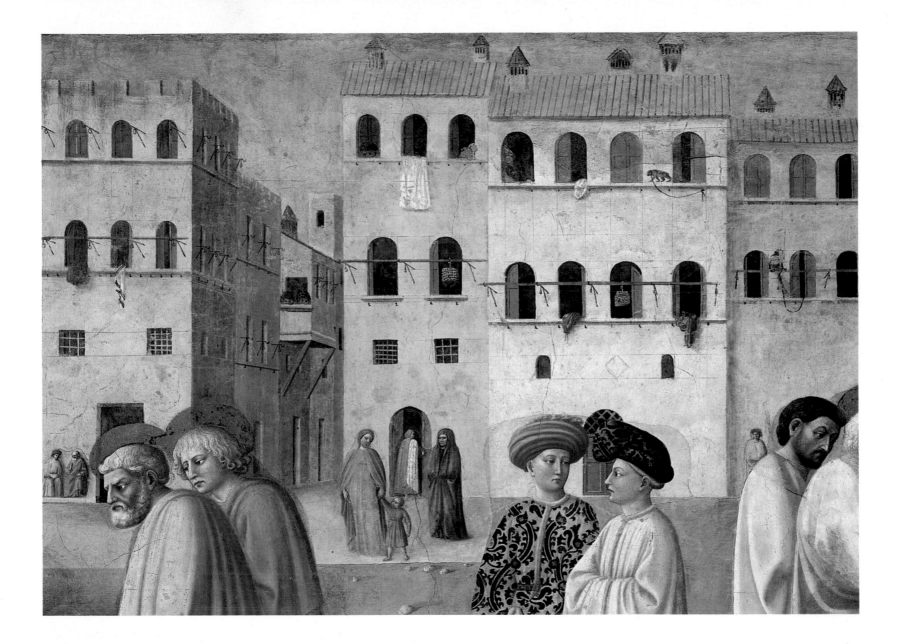

of the supporting cast are less important than the action itself. By combining less than commonplace stories with strongly familiar settings, these episodes from Peter's life, like the story of the tribute money recounted by Matthew, take on the flavor of parables.

Key to our understanding of Masolino's painting are the young men who occupy its center. Although occasionally identified as the two followers of Peter who called the saint to Tabitha's deathbed, they are not much like him. Indeed, as their dress tells us, they are anything but his messengers. Whereas Peter, as Voragine recounts in *The Golden Legend*, turned his back on the material things of the world by his simple dress, these two are cut of different cloth. Dressed in velvet and fur-lined cloaks, colored stockings, and showy turbans studded with jewel-like stones, they are the resplendent blossoms of an urban *campo* and no less delightful to behold than their secular habitat. In a way the pair personify this place: more than its denizens, they are its *genii loci*, its local spirits, but like the tax collector who stands exactly opposite them in the *Tribute Money*, the two youths in Masolino's scene, while perfectly in harmony with the world around them, are out of joint with God. Young and beautiful, adorned with golden hair, they stand in marked contrast to the ragged cripple and to Tabitha, whose bloodless, careworn face wears a pallor as deathly white as her shroud. Looking inward to each other in a way that recalls Adam and Eve in the adjacent *Temptation* and walking with steps that resemble those of our first parents in the *Expulsion*, they pay no heed at all to Peter or to the misery at the margins of their world, any more than they notice the rocky ground at their feet. They seem not to understand that when Christ proclaimed—as Matthew records in the chapter preceding the story of the tribute—"You are Peter, and on this rock I will build my church" (Matthew 16:18), He was referring not only to the apostle but also to the dangerous and inhospitable place that Adam and Eve encountered beyond the gate of Paradise. To some, seduced by the gleam of money or a pearl-studded hat, the world might seem a beautiful garden, but to others it is but a rocky, barren field. The soul, as the late fourteenth-century merchant Paolo da Certaldo advised, "should have two spiritual eyes," one open to the heavenly "goods" (*beni*) of eternal life and the other trained on the terrible punishments of hell. Wrapped in splendid garments, the self-centered and gilded youths in Masolino's painting have given in to the vain, superficial things of the world; simply by their foppish appearance these showy flowers of fashion make us mindful of what they fail to see: the beauty of providence and the greater and lasting wealth of salvation. We might well recall Christ's urging in answer to His own question, is not "the body more than clothing?": "Consider the lilies of the field, how they grow; they neither toil nor spin; yet I tell you, even Solomon in all his glory was not arrayed like one of these" (Matthew 6:25–29). And so, Peter has put the gilded ones behind him not once but twice.

Like the *Tribute Money*, Masolino's image

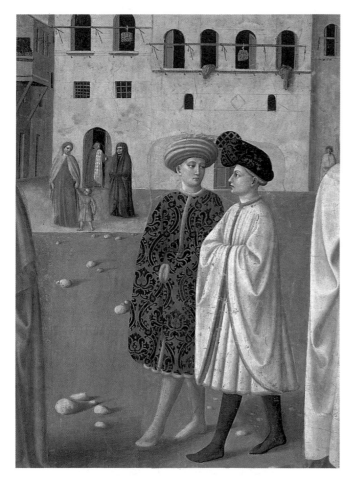

detail, *Saint Peter Healing a Cripple and the Raising of Tabitha*

shows a world that is alluring but as false and worthless as it is fleeting, but whereas Masaccio's story conveyed that notion through the metaphor of money, Masolino's does so through the metaphor of clothing. It is an idea suggested by the account in Acts, which records that when Peter arrived at Tabitha's deathbed, "all the widows came to him in tears and showed him the various garments that [she] had made when she was still with them." In Masolino's painting, whose lower right corner is fairly filled with drapery, two black-robed widows appear at the head of the bier. One of them holds a cloth to her bosom, while the other kneels beside a simple tunic laid prominently on the ground, not only beside Tabitha but directly in front of us. This humble garment recalls the episode of Peter extracting the coin from the fish in the *Tribute Money*, where the saint has likewise placed his cloak on the ground. Moreover, the tunic beside Tabitha's bier, which may be seen as the emblem of a life "marked by constant good deeds and acts of charity," is close in color to the tattered clothing of the beggar cured by the saint's act of charity. Although the beggar asked for money, Peter offered him something else: "I have neither silver nor gold, but what I have I give you," and what he, like Tabitha, received was infinitely more precious. Surely, then, it is significant that the beggar, with his remarkably foreshortened and beautifully fashioned leg so praised by Vasari, hardly seems crippled at all, whereas the youths are shown without hands, as if disabled by the material wealth that covers them.[2]

Confronting each other across the space of the chapel, the *Tribute Money* and *Saint Peter Healing a Cripple and the Raising of Tabitha*, so closely related in theme and specific iconography, were probably also painted in tandem. The evidence suggests that at least on this level of the chapel Masaccio and Masolino worked together until no later than September 1425, when Masolino departed for Hungary probably not to return until 1428. Did he unexpectedly abandon the project to his partner or was it their considered intention from the start that Masolino paint only in the upper parts of the chapel and not at all in the lower? We may never know, but in the upper register, where their work is more intact, they divided the work equally and with a degree of harmony that has the appearance of a plan. Although the labor may have been equal, the driving creative force was Masaccio. We detect this in some of the less successful aspects of Masolino's effort. Like Masaccio, Masolino made Peter into a seemingly three-footed creature in the episode of the cripple, but whereas in the *Tribute Money* the device helps to characterize the saint, here it is a timid, awkward, and ineffective detail. Apparently following his colleague, Masolino even adopted a modular division of his scenes on the right wall and entrance arch according to the same ratio of one to six found in Masaccio's two scenes on the opposite side of the chapel. Like Masaccio, he divided his larger composition, which is marked by a too-prominent vertical axis, into six parts; however, he adopted the idea without understanding it and, unlike

Masaccio, made no discernible effort to link his figures according to this system. Although the suggestion of emptiness at the center of the *Raising of Tabitha* is perhaps intentional, we have to admit that the effect is not especially successful. In the end, Masolino's scene, when measured on Masaccio's terms, lacks the integration and force of his partner's: the whole is less than the sum of its parts.

Masolino worked under Masaccio's irresistible influence in the Brancacci Chapel. We have only to think of a work such as his undated but earlier Contini-Bonacossi *Virgin of Humility*, with its insouciant Gothic rhythms, its sweetness, and its daintiness, to see that in the chapel his figures have greater bulk and simplicity, even though the gently serpentine ripples of Gothic movement still linger in the *Temptation* and in the climactic episode of Tabitha's resurrection. Yet, it also appears that in his turn Masaccio was not unmindful of Masolino. His work here avoids the boldness, the roughness of his earliest known painting, the San Giovenale Altarpiece of 1423, and the difference is due perhaps in some measure to his response to Masolino as well as to the natural process of his meteoric evolution. Setting the two artists' earlier paintings side by side, they seem incompatible, even contradictory. Who dominated the relationship? For the great art critic Roberto Longhi, it was the gentler of the pair. He even argued that Masolino painted the most important head in the *Tribute Money*, a painting otherwise entirely by Masaccio. He noted that Christ's head, which has

the mildness of a lamb's, differs from the "apostolic wolves" that encircle it, and he opined that Masolino must have painted it after his companion had finished the rest of the mural. We now know, however, that the painting was achieved according to traditional mural technique, that is, from top down, so that the head of Christ was far from one of the last sections painted. Moreover, to subordinate Masaccio to Masolino goes against the long and consistent testimony of history as well as the evidence of the works themselves. Yet, the head of Christ, which has rightly been compared to that of Adam in the *Temptation*, is somehow different from those around it: is that difference a possible clue to the painter's intention? It suggests that Masaccio, who made such skillful use of antithesis throughout his work and who varied his technique from one figure to the next in the *Tribute Money*, consciously adopted something of the softness and fineness of Masolino's style. He probably did this, not because he borrowed a drawing by Masolino, which he would hardly have needed for a head of Christ, but rather to set off the head of Christ, to draw our eyes to it, to fix our attention on it, and, thereby, to adumbrate by its luminous calm the omniscience of Christ the teacher and perhaps also to imply the notion of Christ as the second Adam come to redeem mankind from the error of the first.[3]

It is, in fact, within the context of Paradise lost and Paradise desired that we must also consider the scenes that form a natural grouping on the altar wall. Besides the *Saint Peter Weeping* and the *Pasce oves meas*

that flanked the window and that Vasari attributed to Masolino, the wall depicts scenes that the sixteenth-century writer described in generic terms. As a whole, they allude to the pastoral and liturgical mission of the apostles and the church, charged by the Good Shepherd to teach, to baptize, to heal, and to feed. This mission was a matter of importance to the Carmelite monks of the convent, who claimed to trace their ancestry from the prophet Elijah and who, therefore, saw themselves as specially chosen guardians of the true word, not only under Peter and his successors but even during the Old Testament days of Elijah and John the Baptist. They thus make watchful appearances alongside the apostle here and in the scene where Peter assumes his episcopal seat. It is, however, the overriding theme of the entire chapel, namely Salvation, that encompasses the pastoral and liturgical mission of the apostles and the church, including the Carmelite Order. All of the scenes on the altar wall of the Brancacci Chapel are in some way linked to the larger theme of Christ's atonement for Original Sin, the commemoration of that sacrifice in the mystery of the Eucharist, penitence, and judgment. By analogy and by antithesis the scenes on the altar wall are related in formal and thematic ways to each other or to those on the entrance depicting the first parents. In these scenes, as in the *Tribute Money* and the *Raising of Tabitha*, humanity's search for spiritual illumination and well-being is conveyed with remarkable concreteness and immediacy.[4]

MASACCIO
Saint Peter Baptizing the Neophytes

Following Saint Peter's great sermon in Jerusalem, which is depicted on the other side of the window, 3,000 were converted and were baptized. Masaccio has set the scene against a landscape of conical, treeless hills that recede into the distance to the right. This vast space is the background for the somehow intimate action that takes place in the immediate foreground, where Peter is accompanied by figures who are doubtless portraits and who echo the composition of the *Preaching.* The splendidly described figure of the neophyte, or new convert, kneels in the river, as light and water cleanse him of Original Sin. Although his flesh was irreparably darkened by the fire of 1771, we can still admire his physical beauty and the play of light on his body and on the line of his nose and chin. Only in photographs can we observe such details as the way water splashes on his head and drips from his now-damp curls. The shivering youth behind him, who was celebrated by Vasari, seems less solid than his companion in the foreground, for he is painted in a freer technique and dissolved by light in a way that heightens the suggestion that he is shivering in the cold. To further this impression, Masaccio defined his body by means of a quivering outline and, adopting a device from Giotto, has placed him directly in front of a figure dressed in a robe of shifting red shadows and green highlights.

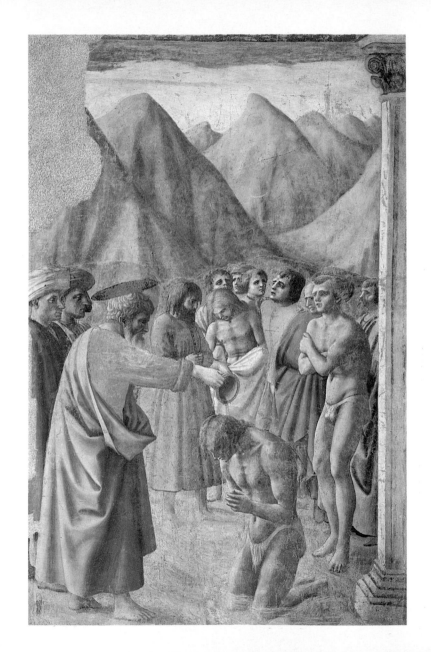

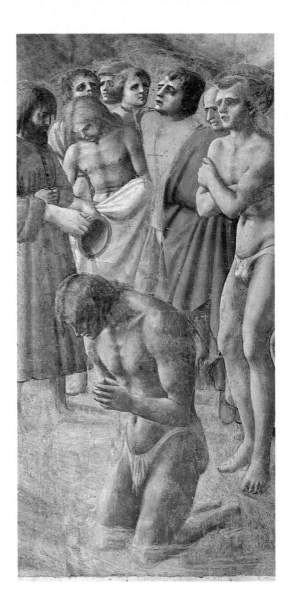

It is a manifestation of the Renaissance focus on man that the image of the human body should become a powerful metaphor in this chapel, which in so many other ways proclaims the ideas of the new era, and this is perhaps nowhere more strikingly clear than in the scenes on the altar wall. The figures in *Saint Peter Baptizing the Neophytes* divide into two contrasting groups, one on the left, including Peter and the crisply delineated and carefully modeled portraits behind him, and another on the right, including the broadly painted and vaguely featured neophytes. The two groups are joined together in the center by two complementary figures, one putting on his blue robe, another taking off his white one. The barren landscape, while linking the scene to the adjacent painting by Masolino, also serves to heighten the impression of distance between the figures in the foreground and those beyond. Distance in this case, however, is more than physical, for the figures undressing or awaiting their turn stand at a spiritual remove as well. Masaccio understood the significance of the ritual as immersion, for he has brilliantly removed the solid ground at the center, so that the figure being purified by the holy water sinks into the river basin and almost beyond the frame. But Masaccio, as Paul Hills has pointed out, also understood the meaning suggested by its Greek name, *photismos,* or enlightenment. A brilliant river of light descends from above, filling the center of the scene with luminous water and bathing the figures with light. In the process, the waiting neophytes seem to dissolve in much the way that the sudden burst of light bleaches and blurs the features of Adam and Eve in the *Expulsion.* While linked in form to our errant parents, the neophytes contrast with their brother in the foreground, once one of them but now purified and cleansed by divine water and light. The vivid beauty of his body, so different from the quivering lumps of flesh that are those who still wear sin, puts his spiritual transformation in terms of a physical metamorphosis. Like the cripple on the adjacent wall and whom he recalls, God's grace has made him whole.

MASACCIO
Saint Peter Healing with His Shadow

This scene is related in the narrative, as in the chapel, with *Saint Peter Distributing Alms and the Death of Ananias,* which is depicted in a corresponding position on the right side of the window wall and which tells of the early days of the Christian community. The scene is set in Jerusalem, in a wide street that enters a temple in the distance. Parts of both the temple and the street are actually painted on the window embrasure at the right since the shape of the field was not perfectly rectangular. The story, taken from Acts (5:12–14), is put in the context of the fear some had in declaring their faith. Although the apostles regularly met in Solomon's Portico, apparently the building espied in the distance, it was not safe:

> *No one else dared join them, despite the fact that the people held them in great esteem. Nevertheless more and more believers, men and women in great numbers, were continually added to the Lord. The people carried the sick into the streets and laid them on cots and mattresses, so that when Peter passed by at least his shadow might fall on one or another of them. Crowds from the towns around Jerusalem would gather, too, bringing their sick and those who were troubled by unclean spirits, all of whom were cured.*

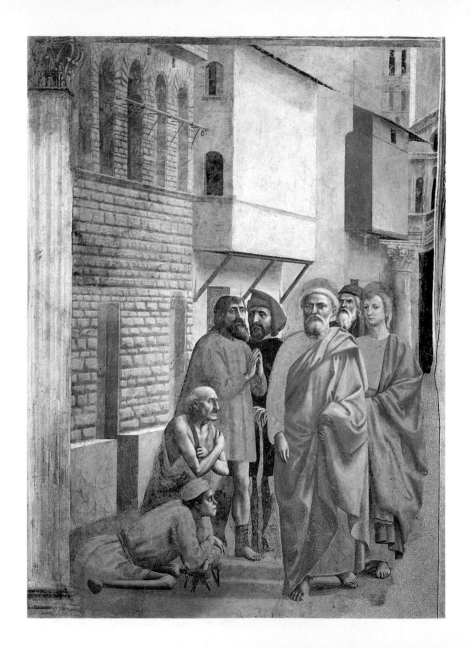

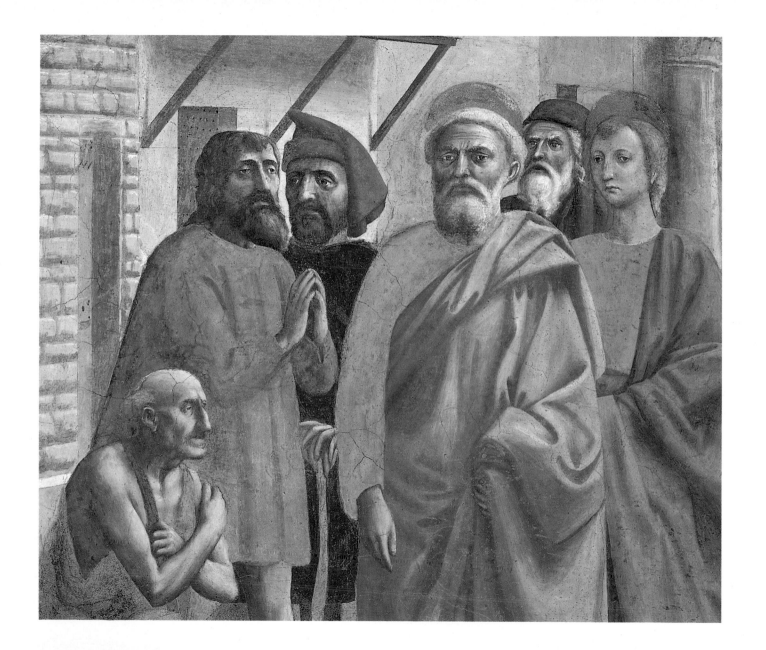

Physical transformation is precisely the outward subject of *Saint Peter Healing with His Shadow*. Masaccio has made this a story about the magical, easily missed, split-second suddenness with which divine grace can work. Time contracts to so small a thing that it seems to stop. Peter, who stares out as if transfixed, seems frozen and still, yet there is a powerful tension between the outward movement of the figures and the opposing direction of the perspective, so that John's drapery fluttering in the breeze and the astonished man and the buildings in the distance suggest, as they will in the work of Uccello, the notion of rushing movement and speed. Moreover, Masaccio has also used distance to suggest the passage of time. We can readily measure what was, what is, and what will be in the quickly rising sequence of figures occupying the left half of the composition, but at the same time, Masaccio fixes the entire story on the infinitesimal moment when Peter's shadow touches the figure in the foreground. The latter is a pathetic creature, so misshapen that he hardly seems human, yet at this instant, when the saint's shadow stretches to him, his hopeful face fills with light and his luminous hand begins to rise in the air. Through God's healing grace, he will rise upright and whole, for as we can see in his already-changed colleagues, who once were what he is, past is but prologue. This instantaneous

physical metamorphosis, which is the essence of the miracle, is the outward sign of an underlying spiritual truth and lays bare the saint's real gift: the happiness, beauty, and comfort of Paradise, where the dehumanizing suffering brought about by the sin of Adam and Eve does not exist.

The healing power of divine mercy, which may come as a voice, water, light, shadow, or some other things and through which mankind can hope to become complete again, is of course a theme appropriate to a funerary setting, but in the Brancacci Chapel, particularly in the work of Masaccio, the images of the dead and broken take on more subtle shades of meaning. They allude to the promise of eternal life, but this idea is put in social and political terms, that is, in material terms: they are the weak and innocent, the lambs of God for whom Peter is responsible, and they are the destitute of the earth who can hope for the spiritual riches of Paradise. In the passage immediately following the story of the tribute money, Matthew records that "the disciples came to Jesus, saying, 'Who is the greatest in the kingdom of heaven?' And calling to him a child, he put him in the midst of them, and said, 'Truly, I say to you, unless you turn and become like children, you will never enter the kingdom of heaven'" (Matthew 18:1–3). And He goes on to warn, in boldly corporeal language, of the

dangers of the material world: "'Woe to the world for temptations to sin! For it is necessary that temptations come, but woe to the man by whom the temptation comes! And if your hand or your foot causes you to sin, cut it off and throw it from you; it is better for you to enter life maimed or lame than with two hands or two feet to be thrown into the eternal fire. And if your eye causes you to sin, pluck it out and throw it from you; it is better for you to enter life with one eye than with two eyes to be thrown into the hell of fire'" (Matthew 18:7–9). In the Brancacci Chapel the cripples and their ilk, who are painted with such sympathy and who are invested with such dignity, are that afflicted body of humanity, the forgotten and vulnerable in man's kingdom, who are rich, beautiful, and worthy in God's sight: the last who shall be first. And those wooden canes, crutches, and stools of theirs are perhaps more than merely their attributes and the inalienable emblems of their suffering. Are they not also their crosses, which remind us that Christ said: "he who does not take his cross and follow me is not worthy of me" (Matthew 10:38)?

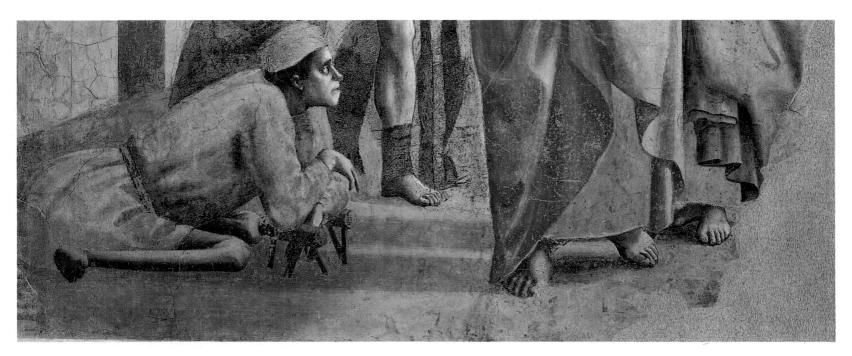

detail, *Saint Peter Healing with His Shadow*

The various themes of the chapel—the contrasts between blindness and sight, wealth and poverty, power and weakness, injury and health, cunning and innocence, the domain of men and the kingdom of God, bodily wants and divine providence—all play a part in Masaccio's depiction of *Saint Peter Distributing Alms and the Death of Ananias.*

Like the story of *Saint Peter Healing with His Shadow*, this scene is taken from the early days of Peter's apostolic mission. Here, the saint, wearing a yellow cloak and accompanied by Saint John the Evangelist and other apostles, distributes alms to the needy members of the new Christian community, who approach from the left. Peter's act of charity is combined with a story of greed. According to the account in Acts (5:1–11), a man named Ananias, with the connivance of his wife, sold a property, but instead of giving all of the proceeds to the church, laid only a portion of it at the feet of the apostles. Peter saw through his cunning and accused Ananias of deception, whereupon he, and later his wife, fell dead. Here, the rich man's corpse is stretched across the foreground and perhaps again as the kneeling figure in the background who raises his hands in offering. A building in the middle distance is placed at an angle, so that its meeting walls and projecting corner restate in architectural terms the central encounter between humanity and God's vicars. Holding open a small pouch whose contents we are not allowed to see, Peter gives alms to a woman carrying a breechless babe-in-arms, as others in need approach: an ancient woman, withered as old fruit, leaning on a cane; a bald cripple, no longer young, relying on crutches and a wooden leg. Despite their deformities, natural and accidental, there is in them, as in the mother and child, a dignity and simplicity belied by their low estate and at odds with the ignobility that brought down Ananias. Like the *Tribute Money* and the *Raising of Tabitha*, this scene is about possessions and inner versus outer beauty; perhaps for that reason Masaccio, going beyond what is demanded by the textual source, developed its central image into a leitmotif. He shows us Peter's pouch, the large sack beside Ananias' corpse, the bag worn by the crippled man, and even something else, for the maiden glimpsed in the distance places her hands on her belly in such a way as to suggest that she herself is a vessel and container. The unseen wealth she carries within alludes to spiritual wealth, providential wealth that the poor enjoy but that the rich man Ananias never had.

But the expectant mother also appears in relation to another figure glimpsed through the crowd: a man kneeling in the distance yet strategically placed at the crux of the composition. His identity has long been questioned, and determining it is not helped by the fact that the lower portion of this damaged scene, notably the figure of Ananias, was extensively reworked, apparently by Filippino Lippi. Even so, we can see that there is a connection between the two figures. Their heads are linked along a vertical axis, and like Ananias, the man who lifts his head in supplication wears bright red robes that in the fifteenth century symbolized wealth and status. Alone among the members of the community, but again like Ananias, the kneeling figure makes an offering; however, does he approach God with an open heart or does he, like Ananias, hope to fool the All-seeing?

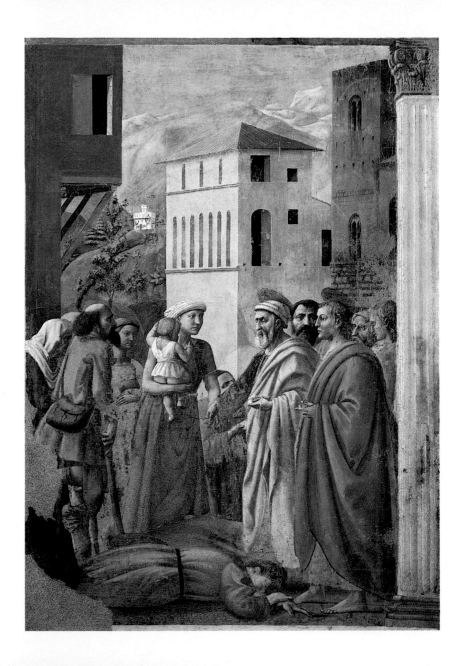

MASACCIO

Saint Peter
Distributing Alms
and the Death of
Ananias

Significantly, Masaccio shows us but one part of his face: his eyes, which, unlike the gleaming lights of the poor, are heavily shadowed and dark. Could it be that Masaccio, fashioning a counterpoint to Peter's charity, has shown Ananias twice, alive and dead, blinded in life by the false lure of material things and, as a consequence of that sinful choice, deprived in death of the true wealth of eternal life? Could it be that Masaccio, hoping to suggest Ananias' unrepentant corruption, has also compared him with the hobbling figure in the left foreground, whose dull red suit is cut like the dress of only one other figure in the cycle: the tax collector in the *Tribute Money*? As Adam and Eve learned, cunning does not profit, and outward things, as we saw in the *Tribute Money* and in the *Raising of Tabitha*, are often deceptive. Sometimes those who seem beautiful, wealthy, and powerful have no prospects, whereas those who seem ugly, poor, and weak, the lambs of God, are the greatest in God's sight.

As in the *Tribute Money* and the *Raising of Tabitha*, Masaccio has made the contrast between inner and outer strength, between inner and outer beauty especially vivid by reference to contemporary experience. Not only does he portray the world with astonishing truth but he peoples it with figures who are carefully observed. The community he shows in *Saint Peter Distributing Alms*, while as varied as its natural and architectural setting and as multifaceted as humanity itself, includes precisely those who in the fifteenth century were most vulnerable and at risk, those at the margins and crossroads of existence: the old, the infirm, the very young, and the daughters of Eve, who all too often died in giving birth. These are the unfortunate "others," who are required to pay tribute in the kingdom of men and for whom Christ, as we know from the *Tribute Money*, paid it.

The juxtaposition of contrasting types in *Saint Peter Distributing Alms* helps to make each figure more vivid and is another manifestation of Masaccio's fundamentally dramatic way of thinking. It also recalls Alberti's advice to the painter in his famous treatise *On Painting* (1436) and Leonardo's dictum: "beautiful things and ugly things appear more forceful one beside the other." Although much has been said about Masaccio's illustration of the Renaissance concept of man's dignity, these figures suggest that his art ought to be put in the context of the larger debate among fifteenth-century philosophers and men of letters, a debate that contrasted man's dignity with his misery. Beginning in the late fourteenth century, humanist writers as diverse as Petrarch, Coluccio Salutati, Lorenzo Valla, Bartolommeo Facio, Fra Antonio da Barga, Poggio Bracciolini, as well as Giannozzo Manetti entered into the discussion, but no matter whether they emphasized man's miserable

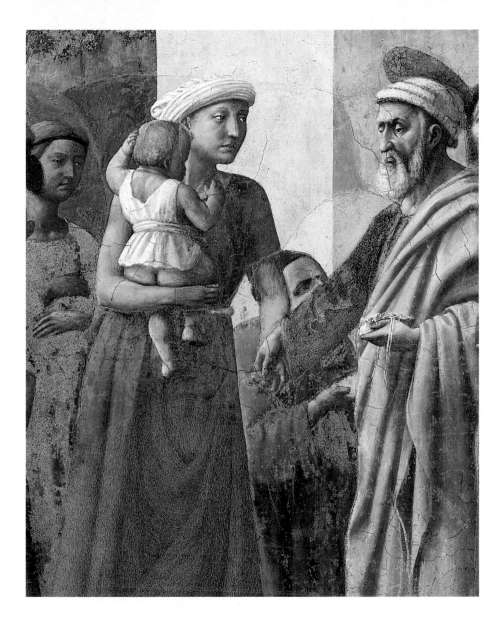

ignobility or his noble dignity, they were aware of its complement. In the Brancacci Chapel, as in Valla and in Barga, who was prior of the convent of San Miniato al Monte in Florence and a friend of Felice Brancacci's ally Palla Strozzi, we find the fundamentally Christian view that life on earth is set beside the promise of happiness in heaven. In the frescoes, as in these writers, man's status is understood in the context of his creation and fall and Christ's atonement and judgment. Man is not inherently bad, for as God's creature, he is beautiful, but sin, which is an element no less active than the serpent in the Garden, confuses, deludes, and brings nothing but suffering and, ultimately, damnation. There is also in the program, again as in Valla and Barga, emphasis on the notion of volition, for man, like Adam and Eve in the Garden and like Peter who obeyed Christ and paid the tribute, or like Peter who later denied him, has it within him to determine his fate, to choose virtue and good, or sin and evil. This dynamic, activist view of man reconciles a Christian focus on God with an anthropocentric preoccupation that is Renaissance in essence; moreover, it corresponds to a consistent effort to engage us, the viewers, in the visual and intellectual fabric of the chapel.

detail, *Saint Peter Distributing Alms and the Death of Ananias*

The kingdom of God and our place in it, as well as man's ability to assure his own salvation is the focus of the two large scenes on the lower level of the chapel. In them Peter is joined by Saint Paul, another sinner whose blind eyes were opened to God. The story of Theophilus, in which Peter converts the pagan king of Antioch by reviving his long-dead son, is paired with the saint's subsequent elevation as founding bishop of the church at Antioch. Opposite these related episodes of Peter's triumph are stories of Peter's trials set in Nero's Rome, where the apostle disputes with the magician

Simon Magus and, failing to convert the emperor, eventually meets his death. Framing these stories are two scenes on the entrance arch: *Saint Paul Visiting Saint Peter in Prison*, painted beneath Masaccio's *Expulsion*, and the *Liberation of Saint Peter from Prison*, which appears below Masolino's *Temptation*. Except for a considerable portion of the story of Theophilus, which was begun by Masaccio, these scenes were painted by Filippino Lippi decades after the initial, aborted campaign to decorate the chapel had come to an end. To what degree Filippino's work adheres to the original plan we

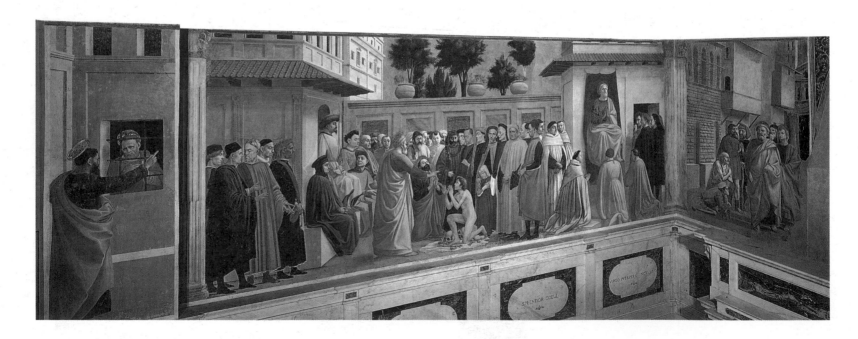

probably will never know. To be sure, he strove to harmonize his usually more unruly and expressive style with that of the early fifteenth-century masters around him. Did he also take recourse to drawings, which Masaccio must have made and may have left behind? In any event, Filippino was bound to respect the iconographic program as he found it; thus, in the context of the rest of the program the contrast between the two rulers, who are tellingly paired across the space, is also about blindness and sight, choice and salvation. Witnessing the

miraculous resurrection of his son, who is placed directly below Christ in the *Tribute Money* in a way that suggests a parallel to the Savior's sacrifice and subsequent victory over death, Theophilus opens his eyes and is converted. Nero, by contrast, refuses to abandon evil. Instead, he remains steadfastly deceived and blinded by the false wizardry of Simon Magus, whom Voragine portrays as the Antichrist. Each one has the power to hear the true word or the false, to choose salvation or perdition.

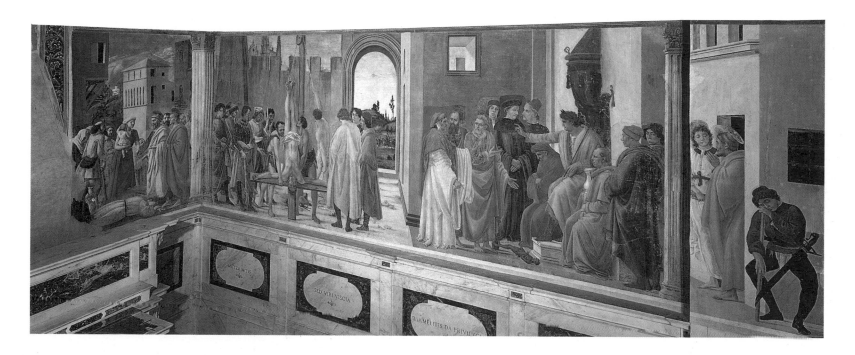

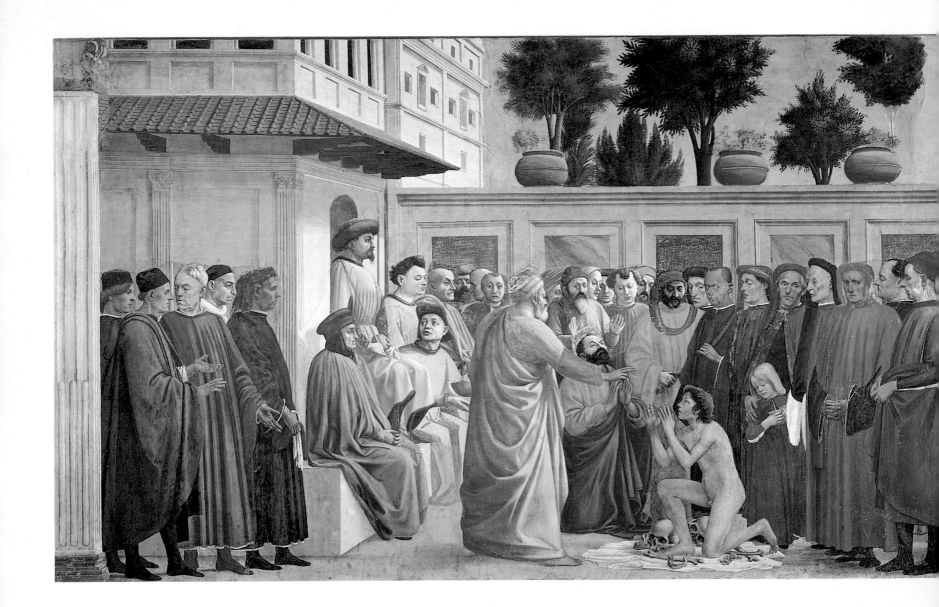

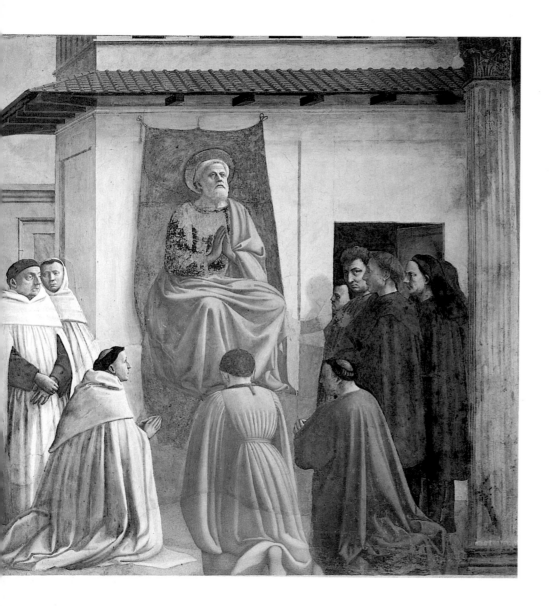

MASACCIO AND FILIPPINO LIPPI
The Raising of the Son of Theophilus and Saint Peter Enthroned as First Bishop of Antioch

This large scene illustrates two related events set in the city of Antioch, where Saint Peter had been imprisoned by the local king, Theophilus, and where Saint Paul negotiated his release in exchange for a miracle. In the presence of the king and his crowded court, which includes numerous portraits, Peter is shown reviving the king's long-dead son, who rises from a white shroud strewn with an odd collection of human bones. According to the account in *The Golden Legend*, the miracle persuaded not only the king, shown to the left of Peter in aloof profile and holding the orb and scepter of power, but also all the people of his city to convert to Christ and to build a new church. Before the structure to the right, whose simplicity contrasts with the classicizing features and elegance of Theophilus' palace, Saint Peter, now designated the first bishop of Antioch, is enthroned on a chair draped with a simple blue-green hanging. Shown in an attitude of rapt devotion, he is elevated to a position higher than that of the king, who now kneels, fur-trimmed hat removed, at the apostle's feet. It is Peter who has greater authority and, as prince of a church whose riches are elsewhere, is enthroned in a humble court, which includes a group of white-robed Carmelite monks, at least one of which is doubtless a portrait. In the fifteenth century, the feast of the chair of Saint Peter celebrated his assumption of the episcopal chair both in Antioch and in Rome; thus, this scene would have been understood as an image referring to the triumphant establishment of the Roman church.

The story of Theophilus is then also about repentance, certainly an appropriate notion for a place where in burying the dead we might very well consider our own end, and Masaccio presented this idea with powerful immediacy. The figure of the enthroned Theophilus, shown holding the orb and scepter of rule and elevated in a way that suggests both pride and authority, is somehow detached from the freely moving, animated figures around him. He stares out with eyes fixed above the crowd, as if he were an unmoving idol rather than a man of flesh and blood, but once converted, he reappears transformed into the subdued figure that humbles himself at Saint Peter's feet. As elsewhere in the chapel, his spiritual conversion is put in terms of physical change, but Masaccio may have sought to make this notion especially vivid and immediate here in the lower register, where the mimetic world of the painting not only draws physically close to us but also takes our contingency more visibly into account. In the eyes of some of Masaccio's contemporaries the scene may have had a startling familiarity and applicability to their own experience, for the figure of Theophilus is probably no imaginary head but the effigy of a specific and notorious individual, Giangaleazzo Visconti, perhaps the most feared tyrant in early fifteenth-century Italy and enemy of Florence. Ruthless, power-hungry, unrestrained by ordinary standards of morality, Giangaleazzo waged a war that almost succeeded in extinguishing Florentine liberty. Thanks only to what was taken as divine intervention did the republic narrowly escape in the summer of 1402, when plague unexpectedly carried off their enemy, then poised for the kill on the Florentine frontier. The memory of that conflict and its providential resolution, if not fresh, may have returned to mind when Masaccio was painting this scene, for the republic was again caught in another impossible struggle against the Visconti, this time, Giangaleazzo's equally ambitious son, Filippo Maria. As Florentines faced the burdens and uncertainties of war against Filippo Maria, there could hardly have been a more compelling and concrete personification of monstrous evil paradoxically combined with hopeful encouragement than the current enemy's father, Giangaleazzo, a contemporary equal to Rome's Nero. Yet, as impossible as it might seem, unlike Nero and like Theophilus, Giangaleazzo was miraculously humbled by divine power. According to the legend, the pagan Theophilus was repentant and in converting even conceded a part of his house to the new church; thus, he appears, hat removed, kneeling at Peter's feet. God's embracing arms, we are told, are wide enough even for the likes of him, and it is this larger theme that is the real subject of the image, for in the gentle figure at Peter's feet we see Theophilus' clothes but not his arrogant face: it is as if in repenting of his former ways, he has become unrecognizable and has undergone a transformation that is physical as well as spiritual.

The *Raising of the Son of Theophilus* is a scene peopled by figures that are somehow familiar and specific as well as others that are almost certainly portraits. Notable among those we can, with good reason, name are the figures in the group at the far right, in

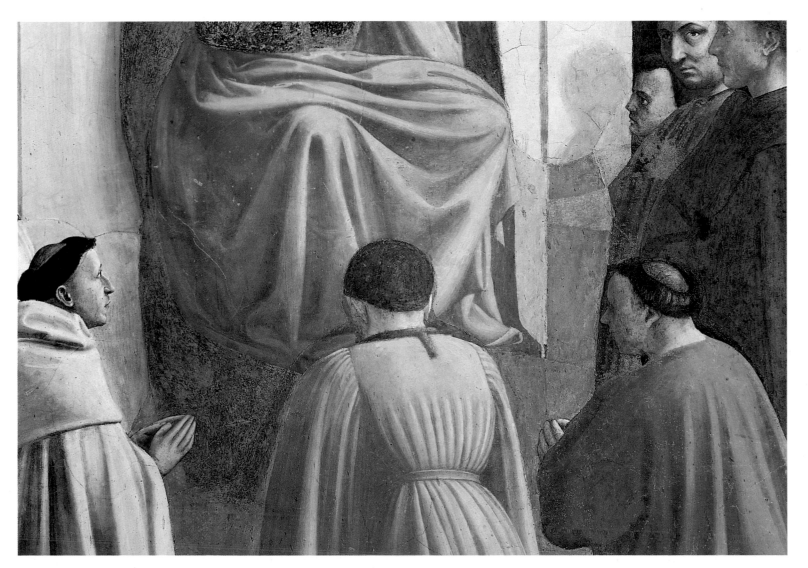

detail, *Saint Peter Entroned as First Bishop of Antioch*

which Masaccio apparently painted, from left to right, none other than Masolino, himself, Alberti, and Brunelleschi. The introduction of portraits, a practice Filippino pursued, makes the concourse between the imaginary world of the painting and our own experience perhaps greater here than in any other scene in the chapel. As Alberti said, "Comparison is made with things most immediately known," to which he added the Protagoran tag that "man is the best known of all things to man." To Masaccio's contemporaries it would have been especially easy to see this scene as an extension of their society and a reflection of themselves. Much has been said about possible allusions to contemporary events in the chapel, and it is hard not to think in such terms. But how finite, how specific would such references have been? Do the scenes of water allude, as some have thought, to Felice Brancacci's maritime interests? Are the *Tribute Money* and the *Death of Ananias* exhortations to civic duty in the context of contemporary discussions about the *catasto*, a new tax legislated in 1427 in part to finance the Florentine republic's defense against the Visconti? Do scenes of taxes in a cycle of the life of Saint Peter, who is a transparent symbol of the papacy, indicate the church's position on the legitimacy of secular authority? Are we to see the cycle as an affirmation of papal power in the context of challenges from John Wycliffe, the Hussites, and the conciliar movement? All of these events and issues are part of the chapel's historical context and cannot be entirely dismissed, but whether they also played a role in its conception and form is another matter. Such things may or may not have entered into the thinking of those who paid for the frescoes, those who devised the scheme, and those who interpreted it; however the program of the chapel operates above all on a higher, symbolic level. We should not mistake as merely topical the devices whose purpose it is to make the larger spiritual aims of the cycle more immediate and meaningful, for in drawing parallels to contemporary individuals and events that are too literal or narrow, we run the risk of trivializing and misunderstanding the transcendent metaphysical aims of the program.

It may seem curious that, along with the living, Masaccio and later Filippino included images of men long dead, but we are after all in a place of burial with the dead under our feet. Theophilus' court, with its remarkable wall encrusted with panels of porphyry alternating with others of marble, is perhaps also meant to allude to the actual mortuary setting, for such panels, while suggesting the sumptuousness of a princely court, are also typical of ecclesiastical furniture, particularly tombs. Above all, porphyry, which is depicted here in remarkably large panels, was especially associated with burial. But in the Christian scheme, death, to which all humanity beginning with Adam and Eve is condemned, will be followed by the resurrection of the body. Did Masaccio wish to suggest as much? Was the revival of the long-dead boy, which is placed under a scene referring to the Passion and which is framed by scenes on the entrance alluding to the soul's confinement and release from its earthly prison, intended to evoke the day when all the dead will rise from their tombs? In that hour men of every rank, kings and clerics, painters and cripples, neophytes and mothers will stand together

as they do in depictions of the Last Judgment. More-over, is it a coincidence that we find a precedent for portraiture in fourteenth-century scenes of Paradise, such as the Giottesque mural in the Bargello and Nardo di Cione's frescoes in Santa Maria Novella? Here, as in those images, specific individuals join each other at the right hand of Christ, whose sacrificed body stood on the altar, symbol of His tomb and cradle in His living presence in the Eucharist. Thus the assembled throng in the *Raising of the Son of Theophilus* includes all manner of mankind, *uomini famosi*, or famous men, notable for their *virtù*, which might be faith or patriotism, as well as humbler folk like painters. The inclusion of portraits is a device of enormous effective power and makes those of us who will one day soon be dead more conscious of our physical and moral selves. This is precisely the not-uncommon warning uttered by the open-jawed skeleton of Masaccio's *Trinity* in Santa Maria Novella: "I once was what all of you are and what I am you too will become." And it is in the context of the hereafter that one odd pairing in the scene is less curious than it seems. Seated at the right of Theophilus or the likely effigy of Giangaleazzo Visconti is a figure probably indentifiable as Coluccio Sallutati, none other than the Visconti's implacable and vocal enemy in the defence of Florence. That he is now made Giangaleazzo's right-hand man, as it were, may have struck some of Massacio's contemporaries as remarkable, but they might thereby have realized that this match, inconceivable on earth, is one that could only ensue in heaven, where all things are possible.

The notion of the resurrection of the body on the day of judgment, in any case the logical end of a cycle that begins with man's fall, is perhaps also implied by the antithetically rising and falling action in the two lowest scenes on the altar wall, and it might have been even clearer had the legitimate conclusion to the story of Nero, the Fall of Simon Magus, appeared on the wall opposite the *Raising of Theophilus*. It might well have, since the *Crucifixion of Saint Peter* originally appears to have been depicted on the wall behind the altar, but probably in the fifteenth century it was hidden from view by the highly venerated thirteenth-century *Madonna* still in the chapel. As a consequence, if Masaccio wished to allude to judgment and to a community of shades come to life on that blissful-remorseful day, what we now see of that idea is attenuated; nevertheless it is the just and fitting climax to which the entire cycle builds. Indeed, the idea is ineluctably connected with the reversal of human misfortune through Christ's Passion, always identified with the altar, and its echo in Peter's crucifixion. Thus, the apostle's death, like that of Christ, should be understood in relation to the final resolution of the epic saga launched by the *Expulsion of Adam and Eve*, a story that traced humanity's fall from grace near God into the uncertainty and suffering of the material world, our world, the world of the chapel itself. Indeed, blindness and sight, error and repentance, choice and judgment are themes that also play a part, as Voragine records, in the final episode of Saint Peter's life, where speaking from the cross and in the throes of

death, the apostle explained his last choice in terms that resound throughout the Brancacci Chapel: "Lord, I have desired to follow Thee, but I did not wish to be crucified upright. Thou alone are erect, upright and high. We are children of Adam whose head was bowed to the ground: his fall denotes the manner in which men are born in such wise that we are let fall prone upon the ground. And our being is so changed that the world thinks that left is right, and right is left."

But the *Raising of the Son of Theophilus* is also about the kingdom of art. To judge from what remains of Masaccio's work, it was to be a formal as well as an iconographic climax to the cycle. It is certainly more elaborate than the *Tribute Money*, and offers a striking and perhaps intentional contrast to the great painting above it.[5] It also belies Landino's characterization of Masaccio's work as "pure, without ornament," but it is worth remembering that when Landino's text appeared in 1481, this scene almost certainly stood incomplete and perhaps vandalized: he might well have ignored it. Still, it is in many ways an astonishing work. With its crowd, whose density Filippino only appears to have lessened, the *Raising of the Son of Theophilus* is perhaps the one surviving work by Masaccio that gives us an idea of a slightly earlier image that he painted in the cloister of the same church, the *Sagra*, a monchromatic mural achieved in *terra verde* and commemorating the dedication of the church of the Carmine on April 19, 1422. Of this image, which is echoed by several drawings, Vasari praised the way Masaccio was able to show, as he does in the *Raising of the Son of Theophilus*, figures five and six deep and the way he introduced a host of portraits. The similarities between the two works may

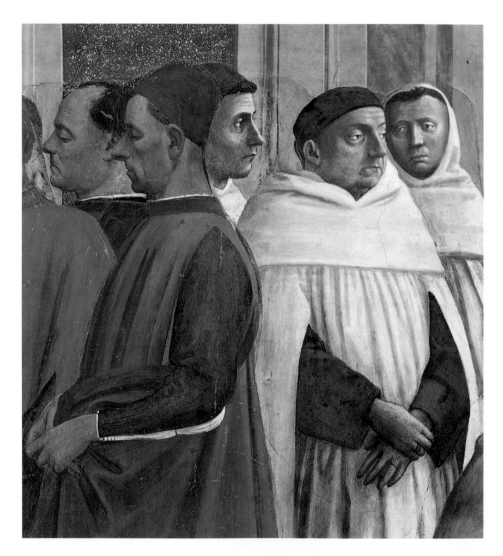

detail, *The Raising of the Son of Theophilus and Saint Peter Enthroned as First Bishop of Antioch*

not have been lost on Filippino. Vasari also notes that among the assembled citizens in the *Sagra*, Masaccio included the gatekeeper standing key in hand, and in the *Raising of the Son of Theophilus* the figure that Filippino shows with his back to the group of Carmelite friars also hold a key, an image that is appropriate for a cycle devoted to the keeper of God's kingdom.

The arrangement of figures in depth is a problem of perspective. Earlier painters could simply stack figures in vertical ranks, one behind another, a solution that was orderly but contrary to the rules of vision. Masaccio's figures, who occupy an extension of our world, obey our laws. We catch glimpses of them as they crane their necks, lean over each others' shoulders, and try to see the miracle that for most of them is out of view. And like any group of people who might find themselves at such an out-of-the-ordinary event, they gesture their surprise, look out in astonishment, ponder the mystery in reverent silence, or turn to discuss it with their neighbor. There is in Masaccio's figures a casualness, spontaneity, and variety far more convincing than in any of his other surviving paintings.

There is, however, little that is haphazard about what Masaccio does here. After all, the scene is related in visual as well as iconographic terms to the *Tribute Money* above. For instance, the irregularly spaced urns on the wall seem casual, but in fact they, like the principal figures, correspond to significant points in the *Tribute*. The crowded S-shaped composition of *Theophilus* echoes the underlying structure of the *Tribute*. Indeed it even follows the *Tribute*'s modular system, and the figures' general groupings, which Masaccio must have determined, correspond precisely to the three episodes in the *Tribute*, not only in terms of position on the wall, but also according to their relative importance in the narrative. Thus, the central miracle, echoing the central confrontation above, is given the greatest weight, three modules, whereas the chairing of Peter is two, and the group of advancing spectators at the left is one.

In *Theophilus*, we even detect the echo of the system, whose full complexity, alas, we will never know, in the placement of some of the figures in an area where Masaccio's design survives, namely, in the figures that appear at the left end of the paneled wall of Theophilus' court. However irregular and, therefore, natural their placement appears, it is nonetheless the result of skillful, measured calculation that is not only more complex than in the figural arrangement of the *Tribute Money* but even playful. Peter and the dark-haired figure in green seated to the king's left are aligned with the moldings around the leftmost panel of the wall, which serves as a convenient ruler. The remaining figures between them are similarly paired and approach the central axis of the porphyry panel in regular increments, as if they were points on a graph rather than objects in space. Thus, the figure staring out at us in wonder, a figure reminding us of some of Uccello's work, has as his partner the magnificent attendant who casts his spherically drawn eyes in a backward glance up to the king. This pair is followed by a more obvious one: two bald heads, who bring to mind Donatello's contemporary *Zuccone*. They frame a brown-bearded man, who is placed precisely along the central axis of the porphyry panel; looking down his fore-

shortened nose, he inspects us through narrowed eyes, as if he were a cat.

As Uccello will later suggest, there may be one vanishing point in a perspective system, but there are an infinite number of points of view in nature. Masaccio's figures look in almost every direction and from a variety of vantage points; they are so believable that they encourage us, by the power of suggestion, to do what they are doing: to look, search, and analyze with our eyes, the chief instruments of our rational selves. This is but a more subtle version of a device recommended by Alberti, who urged the painter, presumably as a way of guiding the viewer, to show one figure who simultaneously looks out to catch the spectator's attention and points into the painting. The figures in Masaccio's painting are as aware of us as they are of themselves, and by their action of looking they urge us to a higher consciousness of our physical selves. When we follow their example and look around, we find all manner of odd things happening in the image. According to the laws of perspective things seem to diminish as they recede, but do they always? The frame cuts off Theophilus' splendid Brunelleschian palace, so that the windows that run parallel to the picture plane are like dark horizontal dashes, but then a corner turns, a wall recedes, and the windows, instead of getting smaller, grow taller, taller, and taller. At that point in space, and moving to the right in the painting, the top of the wall becomes another ground line, and our point of view is now sharply lower, so the receding trees beyond diminish as if they are being radically truncated, so to speak, from below. This *amuse bouche* or, better, *amuse yeux*, is precisely the perspectival device that Mantegna will put to very different use in his *Martyrdom of Saint James* in the Church of the Eremitani in Padua.

The altering effect that our point of view has on how we perceive a thing restates a theme of the chapel: things are not what they seem in this world of sunlit matter, but in the *Raising of the Son of Theophilus* we notice an interest in optics as well as morality or, as Brunelleschi himself said in a sonnet, an effort "to make visible to others that which is uncertain."[6] Because of our point of view, we see the edge of the receding eave of the building on the right from below. The line of the eave is a firm edge, but the roof above Theophilus' head is a more ambiguous thing. Lower than the first, it presents its entire tiled surface as a sharply flattened parallelogram. It has been distorted in much the same way as the wall, which we know is really a ledge, even though it looks like nothing more than a line, too thin in any event to support those monochromatic terracotta urns that are in themselves a demonstration of construction achieved through pure chiaroscuro. But even these pots, from which two trees playfully seem to sprout, are perhaps not what they seem. We wonder if these oddly squat things, here foreshortened sharply from below, are not the unrelieved victims of the laws of vision, that is, if Masaccio is showing us, rather than the thing itself, the thing distorted as the eye would see it.[7]

detail, *The Raising of the Son of Theophilus*

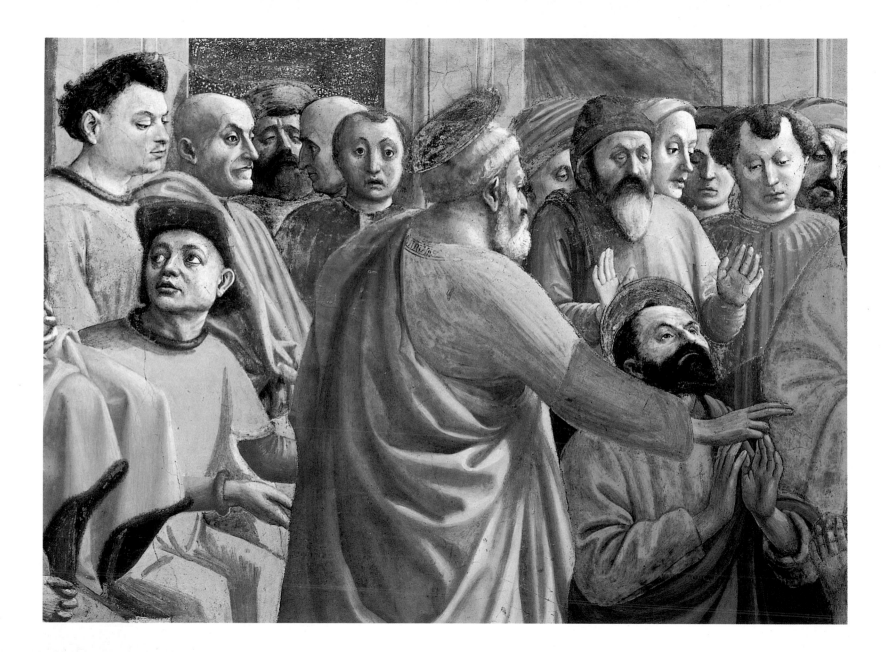

Masaccio knew that sometimes solid things seem to appear as if out of nowhere or disappear along with space. Distance seems to vanish between Theophilus' palace and his courtyard wall, which continues behind the humble structure on the right and by implication also behind the palace to the left. Space thus seems to contract to a line, or the fold of an envelope, and by the same token rabbits come out of hats: at either end of the scene groups of figures enter the stage past the Brunelleschian pilasters of the frame, almost as if out of magical air. For Masaccio the frame has become a kind of giant passe-partout, and as if to confuse us further, the group of figures at the far right of the scene, namely, Masaccio and his artist friends, appear before an enframing doorway that is open but impenetrably black. But perhaps we should expect the unexpected in a scene where the principal characters are shown in vanishing profile![8]

It may seem ironic that a scene peopled by so many dead should be rendered with such joie de vivre, but the dead in the *Raising of the Son of Theophilus* are no longer dead. Like Saint Peter, Masaccio has revived them and miraculously allowed them to join the living, including us. In so doing, he perhaps also intended to revive a theme in ancient writings about art: the vivacity of dead painting, one later developed by Vasari and others during the Renaissance. In any event, Landino

and others praised Masaccio precisely in just such terms, and his art is filled with what Alberti called the "miracles of painting." So full of life and so full of curiosity was he, and so fast was he developing, that we can only wonder how much the young painter might have accomplished with a just a few more years, not to mention a decade or the lifetime granted others. Already in the *Raising of the Son of Theophilus* we espy enough inspiration for the next generation of artists and beyond: not only Fra Filippo Lippi, Fra Angelico, Paolo Uccello, Andrea del Castagno, Domenico Veneziano, Piero della Francesca, and Domenico Ghirlandaio, but also Leonardo, Raphael, and Michelangelo. The Brancacci Chapel, as Vasari said and as the young Filippino must also have recognized, quickly became something of a shrine, a place where the principles and secrets of the new movement were free to those who could see them and where artists could learn as brothers.

The fraternity of artists, another theme beloved by Vasari, is a notion perhaps suggested by Masaccio himself. In that grouping in the right corner of the *Raising of the Son of Theophilus*, we see him self-portrayed along with his collaborator Masolino, with Alberti, and with Brunelleschi, who upon hearing of Masaccio's death is said to have kept repeating, "We have suffered a great loss." The four colleagues crowd together at Saint Peter's chair, where Masaccio, as if act-

ing for them all and as if in answer to his doubting name, stretches out a gifted hand to touch the saint. Although each one is an individual, as distinct from his neighbor as from each of us, together they are also part of a larger community that includes not only the Brancacci clan but all of the children of Adam and Eve, and for that reason perhaps, impossible though it is, Masaccio and his brothers in art cast but a single shadow against the wall.

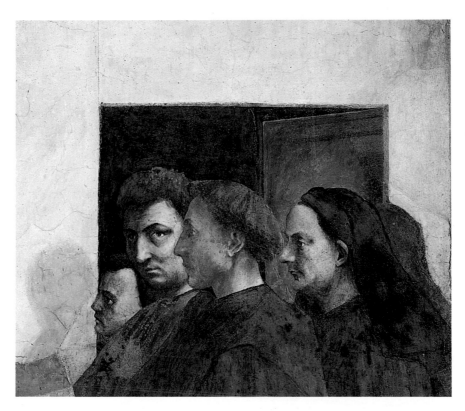

detail, *Saint Peter Enthroned as First Bishop of Antioch*

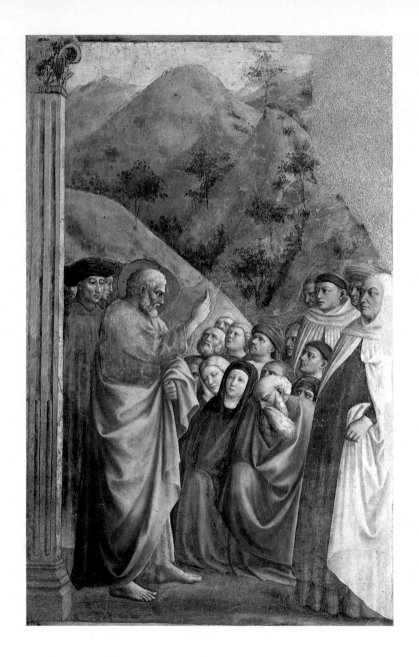

Saint Peter Preaching

After the Pentecost, on which day the Holy Spirit descended upon the apostles and granted them the gift of tongues, Peter delivered a sermon in Jerusalem and urged all present to reform and be baptized, warning against the corruption of the world: "Save yourselves from this generation which has gone astray" (Acts 2:14–41). His words caused no fewer than 3,000 to be baptized that very day, an event that is depicted in the corresponding scene on the right side of the window. Here, mouth open in speech and gesturing toward heaven, Peter stands before the faithful assembled before wooded hills made visible by the recent conservation campaign in the chapel. Behind him appear figures in contemporary dress, the first of whom in blue is possibly a portrait. To the right, white-robed figures of Carmelite monks, at least one of whom appears to be a portrait, have also come to hear him spread the word. Their presence emphasizes the Carmelites' claim to be the oldest of all the monastic orders. Dating their origins to the Old Testament and in particular to the prophet Elijah, the Carmelites claimed for themselves a special role as guardians of Christ's church.

(Right) As at any sermon, even one by the prince of the apostles, not all ears and eyes are open. Masolino has delighted in showing, in addition to the sober-faced Carmelites who stand in attendance to the right, the soft and delicately rendered features of men and women of every age and condition. A widow wrapped in a black habit, not unlike that worn by the widows in the nearby *Raising of Tabitha* by Masolino, lifts her gently luminous face and listens attentively, but her nearest neighbors, a bald man with a lush white beard and a girl with blond hair and flesh as fair as a dream, cannot keep awake. Others stretch their necks, look on earnestly, and heed, but perhaps only the rapt face of an open-mouthed innocent in the second row conveys the wonder of revelation. And, then, a figure whose face is barely glimpsed to the left of the sleeping girl in the front turns a searching eye to us.

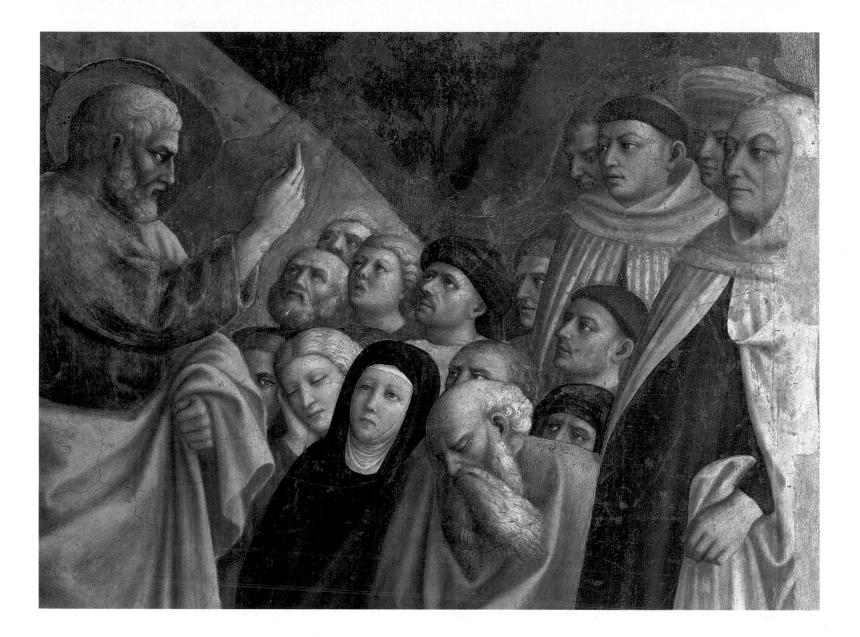

FILIPPINO LIPPI
Saint Paul Visiting Saint Peter in Prison

According to the apocryphal story drawn from *The Golden Legend*, the apostle Peter was thrown into prison by Theophilus, the pagan ruler of Antioch. He would have remained there had it not been for the intervention of his fellow apostle Paul, who told the king of Peter's great powers, which included raising the dead. Upon hearing this, the king agreed to release the apostle on one seemingly impossible condition: that he revive his son, dead for fourteen years. Filippino shows the subsequent episode, when Paul went to Peter to urge him, for the sake of the church, to prove Christ's power by means of a miracle. The two saints, who were closely connected in the history of the early church and who later shared feast days, converse through the barred windows of the jail. Paul, his body echoing the forms of Adam and Eve in the scene above, encourages his somehow uncertain friend with a commanding gesture toward heaven and in the direction of Christ in the *Tribute Money*. This quietly powerful scene, which was at one time attributed to Masaccio rather than to Filippino, has a simplicity and clarity that is part of Masaccio's legacy, as is its subtle play of light and shadow. The latter can be dramatic, as in the way that Paul's finger is silhouetted against the black background of Peter's cell, but also poignant, as in the way that the firm features of Paul's profile and the trembling form of the shadow cast by Peter converge against a line of light at the left corner of the cell's window.

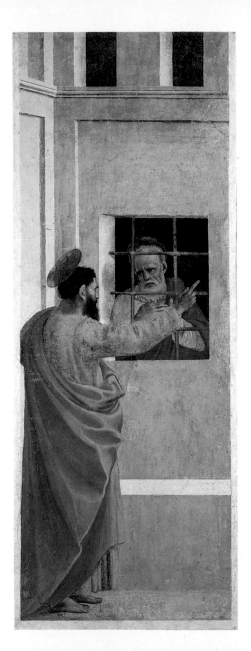

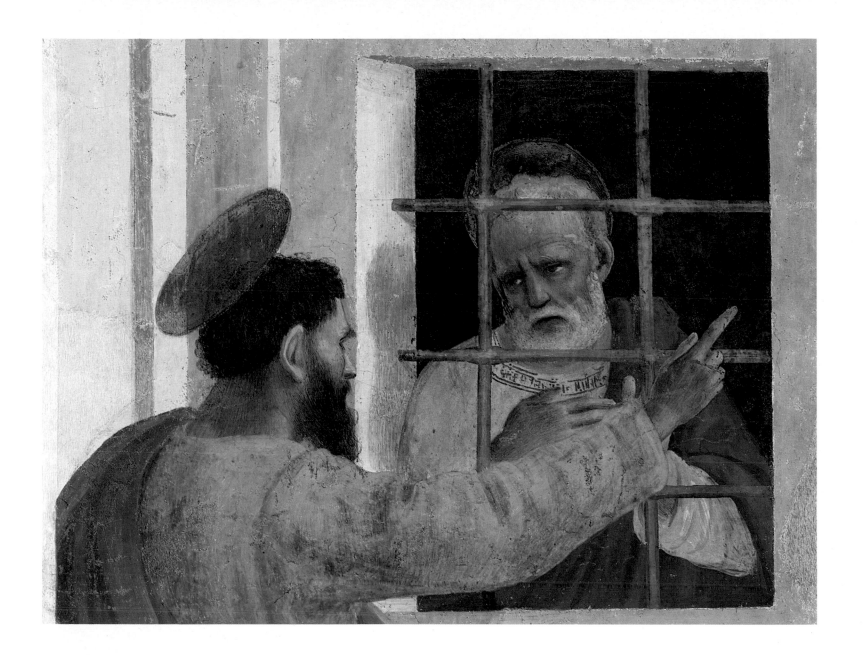

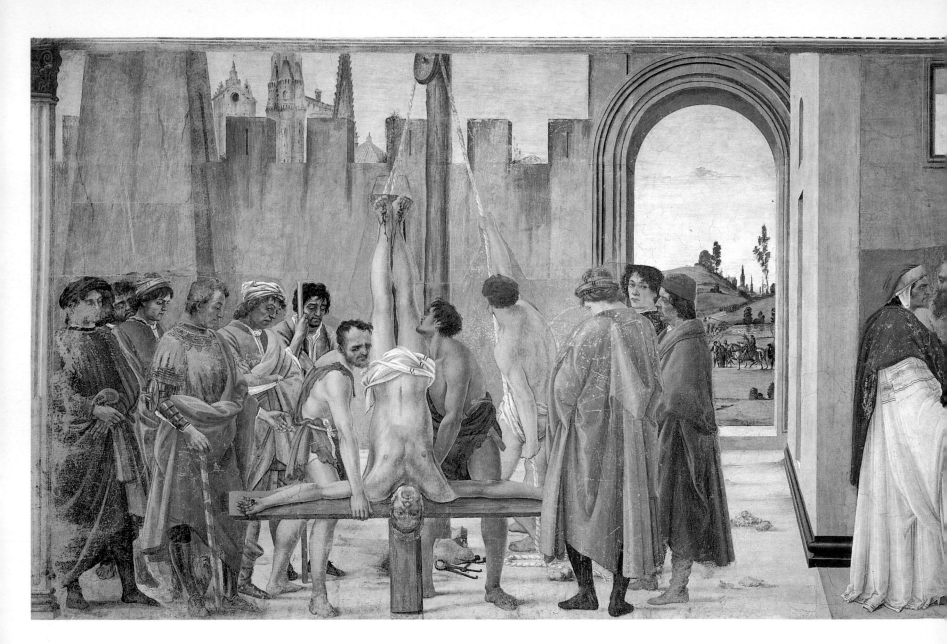

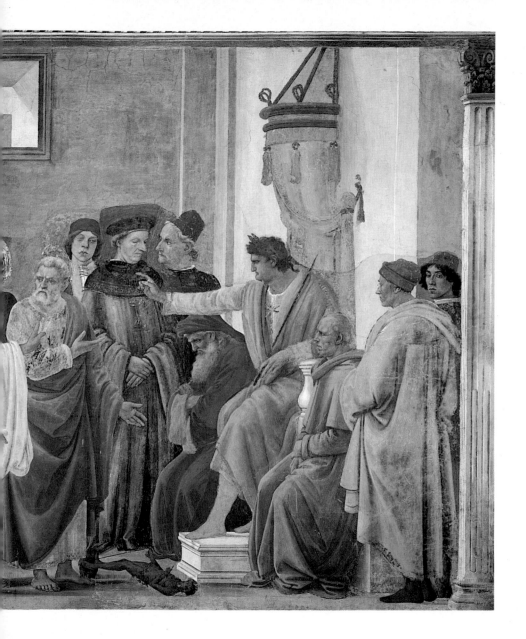

FILIPPINO LIPPI
The Crucifixion of Saint Peter and Saint Peter Disputing with Simon Magus

This image illustrates two episodes, both drawn from *The Golden Legend* of Voragine and both set in the Rome of Emporor Nero: the death of Saint Peter by crucifixion on the left, and Saint Peter accompanied by Saint Paul, disputing with a magician named Simon, on the right. Simon Magus, whose false wizardry serves as a foil for Peter's true power through Christ, competed with Saint Peter for many years, first in Jerusalem, where he even falsely professed Christianity, and eventually in Rome. He was, in fact, a dissembler and was even able to make his face change from one aspect to another. Although he impressed the Roman people so much that they erected a statue to the "god Simon," in his heart he envied Peter's ability to raise the dead in Christ's name, and even tried to bribe the saint to share his power (hence the term "simony"), but Peter consistently rejected him, exposed him, and defeated him. Each time, however, the fraud was able to regain the resolutely blind Nero's favor.

Simon Magus is seen at the left of the scene of *Saint Peter Disputing*, clothed in a white robe and red cloak. Filippino suggests Simon's chameleonic power by showing him with the facial features of Dante, but he also suggests that this is merely a two-faced deception by making his imitation of the great Christian poet of the *Divine Comedy* not quite believable. That this is yet another moment when Peter has exposed Simon as an impostor is suggested by the overturned statue girded with ivy on the ground. But Simon has nevertheless apparently persuded Nero once again: Simon sticks an accusing finger in Peter's chest, and

with his other hand he indicates the graven image on the ground. That diabolical object in turn points towards the emperor, who gestures toward the other side of the composition and orders Peter's execution. The story, which looks forward to the apostle's own death, also alludes to the false magician's demise. Claiming that he was going to abandon Rome and ascend to heaven, Simon, wearing—as Nero does in Filippino's fresco—a crown of laurel, jumped from a high tower and flew about supported by demons. Voragine then writes: "Paul lifted his head, saw Simon flying about and said to Peter: 'Peter, linger not to finish thy work, for already the Lord calls us!' And straightaway Simon was dashed to earth, his skull was split, and he died."

The left half of the composition depicts Saint Peter's matrydom. After the death of Simon Magus, Nero vowed to punish the apostles, and the danger caused Peter's friends to urge him to leave Rome. This he did, but on his way out of town "he came face to face with Christ himself; and he said to him: 'Lord, wither goest thou?' And our Lord responded: 'I go to Rome, to be crucified anew!' 'To be crucified anew?' asked Peter. 'Yes!' said our Lord. And Peter said: 'Then, Lord, I too return to Rome, to be crucified with Thee!'" Peter thus knew his death was near, and in due course he was arrested, an episode that Filippino depicted as taking place near a body of water seen through the arch at the center of the composition, where we also see Peter being led with his hands bound behind his back. Unlike the apostle Paul, who was a Roman citizen and was accorded the greater dignity of being beheaded, Peter was crucified like a criminal, but out of humility he asked that he die upside down.

detail, *The Crucifixion of Saint Peter*

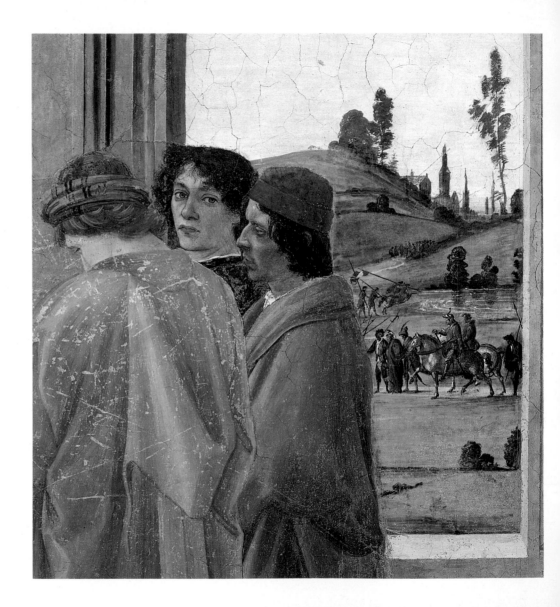

(Opposite page) Two of these three subtly varied figures appear to be portraits, and the one looking out is thought by some to be a portrait of Filippino's teacher, Botticelli. The figures in this group are painted with skill and economy. Delicate strokes of gray help to model their features and to suggest soft shadows. These three youthful heads present a dramatic contrast with the more coarsely featured henchmen to the immediate left of the cross. Moreover, the group serves as a frame for the martyrdom of Saint Peter, which takes place in the foreground to the left, and is a link with the episode of Peter's arrest, visible in the distant, sketchily rendered landscape of grassy fields, interlocking hills, and rippling water. Against the backdrop of a hunter on horseback, two soldiers wearing contemporary dress lead away the saint, who is shown wearing his characteristic blue and yellow-orange robes and with his hands bound behind his back. Behind them follow an officer in armor and another figure on horseback.

(This page) These two heads, placed on either side of a projecting corner, link the episode of Saint Peter's liberation from prison to the scene of *Saint Peter Disputing* and Peter's crucifixion. They are skillfully contrasted in terms of age, color, pose, and light, that is, according to the lessons Filippino apparently learned from Masaccio in this chapel. One is shown in slightly disappearing profile and silhouetted against a strongly lit wall, whereas the other emerges from shadow to engage our eye. The latter is in all likelihood a self-portrait, which Filippino, then in his mid-twenties, placed, perhaps knowingly, in a position diagonally opposite Masaccio's probable self-portrait in the *Raising of the Son of Theophilus*, painted when the latter was about the same age.

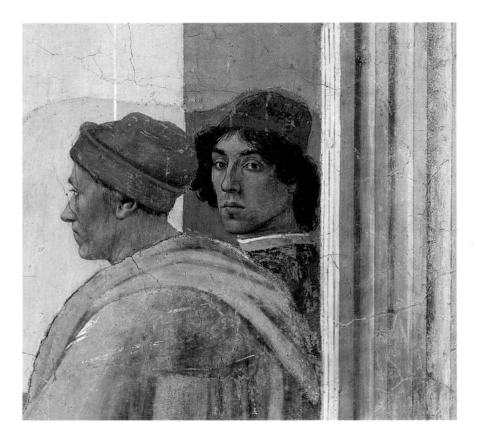

detail, *Saint Peter Disputing with Simon Magus*

Among the courtiers around the emperor's throne, Filippino has introduced portraits of contemporary individuals, including perhaps the painter Antonio Pollaiuolo, that is, the figure in the red cap immediately to the left of Nero. Their pensive, almost melancholy expressions contrast with the forceful—and rash—action of the emperor, who is thereby set apart from them and identified with Simon and the statue. Nero's face is consciously reminiscent of classical heads, but instead of dignity and nobility, its darkened flesh, curled lip, and above all its heavily projecting brow invest it with an air of cruelty that is a sign of both his ignorance and his ignominy.

Unfortunately, the condition of these figures is imperfect. Damage and loss is particularly evident in the area of the mouth of the youth at the left but also in the flaked robes of all the other figures. Originally the surfaces would have had a smoothness and perfection that made Filippino's modeling and poetic light effects subtler and more effective.

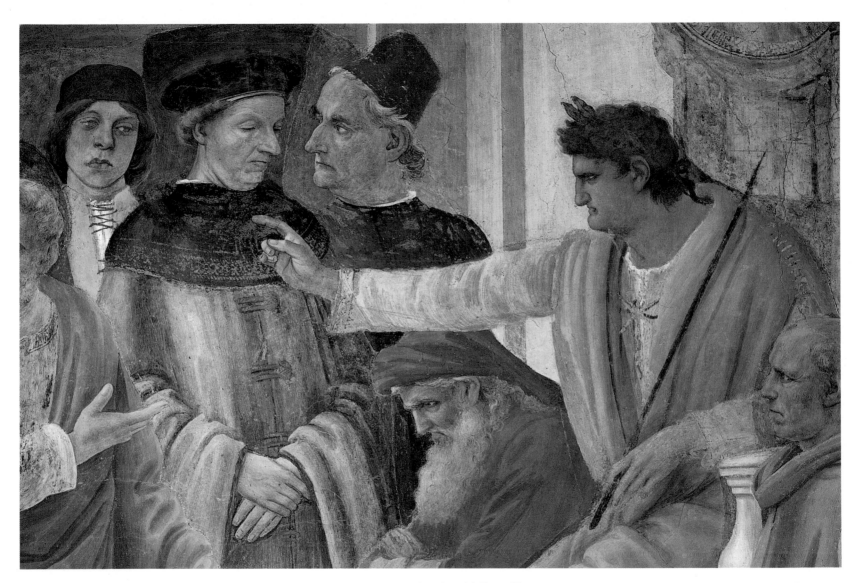

detail, *Saint Peter Disputing with Simon Magus*

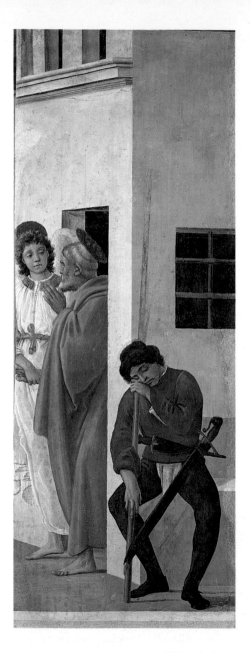

FILIPPINO LIPPI
The Liberation of Saint Peter from Prison

According the the account in Acts (12), King Herod, who was then persecuting Christians, had Saint Peter arrested and thrown into prison with the intention of eventually presenting him to the people for judgment. He thereby hoped to win favor, much as he had earlier by executing James, the brother of John. But on the night before Peter was to be brought to trial, while the saint slept bound by two chains, an angel miraculously entered his guarded cell and "tapped him on the side and woke him. 'Hurry get up!' he said. . . . Peter followed him out, but with no clear realization that this was taking place with the angel's help. The whole thing seemed to him a mirage." The story, which is set in the days of Passover and is thus connected to Christ's Passion, may be seen as an allusion to the liberation of the soul from its own earthly prison, the body.

Filippino has created a scene of the most soothingly delicate poetry. He has contrasted the heavily shadowed and sagging features of the sleeping youth, dressed in fifteenth-century dress, who plays the guard, with the similarly featured but far more luminous and quietly commanding face of the angel, whose curls are silhouetted against an aura of light and whose diaphanous draperies dissolve to such sheerness as to reveal the pale flesh of the body. Equally subtle, the pointed features of the saint's profile are silhouetted against the melting gray of the angel's wing, whose curving, golden edge links the two heads together. Taking the apostle by the wrist, the angel leads him from the penumbral darkness of his cell, through the half-shadowed door, and into a spectral light that is at its most intense above the guard's head.

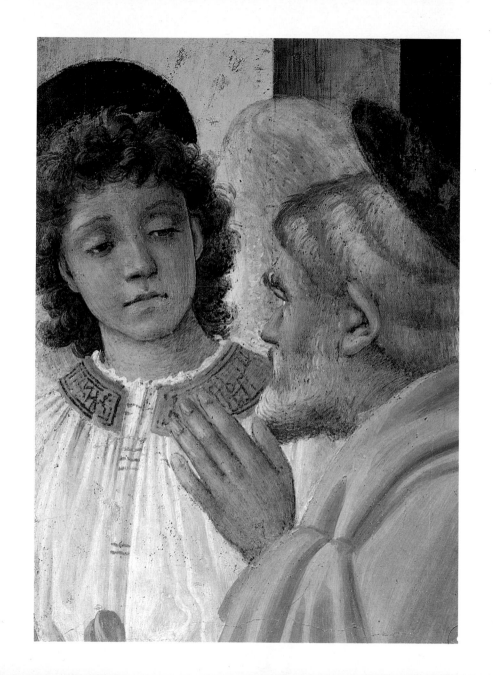

Notes

1 The word *posta* meant not only a post but also a bookkeeping entry or even a place where taxes were collected, and a tax is still termed an *imposta* in Italy. Whether taxes were at one time actually collected at a public place marked by a post of some kind remains uncertain, but in any case the term *posta ferma*, meaning literally "fixed spot," also signifies a business transaction completed or an account settled.

2 To fifteenth-century Florentines and particularly to the Brancacci, who were, after all, silk merchants, the imagery of clothing could hardly have been more concrete and relevant as a symbol of material wealth than money itself. These two things, money and cloth, in fact, reflect the basis of the fifteenth-century Florentine economy, built on banking and the manufacture and trade of cloth. Beyond that, we have to remember the more bedazzling effect clothing must have had on the popular imagination of the day. As late as the sixteenth-century, a German merchant's pre-adolescent son would beg not only for a pet, as a child might today, but also for stockings of many colors, satin purses, boots, and spurs, and even an Italian opera hat. On one occassion the boy's mother writes her husband, "you must have a satin purse made for little Balthasar," adding "he tells me every night that you are bringing him one," or in another letter: "little Balthasar warmly greets you and he has charged me to ask you to bring him a pair of red stockings and a purse." But clothes, as sumptuary laws attest, were not entirely free of moral danger. Thus the same merchant, then in Lucca, writes

his wife about a young man in his charge: "His father writes and begs that he not be allowed to do anything improper, or to wear expensive of silk clothing, all of which happened before."

3 Although Longhi compared the two painters' collaboration to a "concert of the deaf" (a phrase whose perfect wit is sensible even to those of us with imperfect hearing), it was instead as harmonious as the music produced by different but complementary sections of an orchestra. Indeed, the style of one sets off the other in much the same way as they are related to each other in another collaborative work, the *Virgin and Saint Anne,* probably painted in 1424. In the latter panel, Masaccio, as most agree, painted the Virgin and the Christ Child at the center, whereas Masolino was responsible for most of the angels at the margins. The combination of the two styles in the painting has an iconographic and aesthetic motive: it heightens the effect of tangible, projecting relief and in the process, by making Christ seem especially solid, in this particular context, furthers the notion of the real presence of Christ in the sacrament of the Eucharist. As the eye moves from Christ and the Virgin to Saint Anne and the angels, forms soften, sweeten, and are etherialized, as if melted by real and metaphysical distance. By means of this stylistic counterpoint, the two painters not only sharpened each other's individuality and showed each other's strengths to advantage, but they also conveyed an essential truth.

4 The penitent Peter, who weeps out of guilt after having thrice denied Christ

early in the Passion, was placed on the same side of the chapel as the agonized figures of Adam and Eve in the *Expulsion*. By the same token, Christ's innocent flock of lambs, which awaits sustenance in the *Pasce oves meas*, an episode that occurred late in the Passion story, appeared on the side with Adam and Eve eating the deadly fruit. The innocents who hear Peter preach the true word invite comparison with the similarly naive Adam and Eve who are seduced by the false word in the *Temptation*, and the broadly described body of the shivering youth, who stands before a leafless landscape waiting to be cleansed of Original Sin, echoes the freely painted figures of Adam and Eve in the *Expulsion*. The antithetical movements of the lowest pair of scenes, rising with those who are healed in *Saint Peter Healing with His Shadow* and falling with Ananias' death in *Saint Peter Distributing Alms*, corresponds to the action in images of the Last Judgment, in which the blessed are elevated to the right hand of Christ, while the damned are humiliated to his left.

5 *The Tribute Money* contains thirty-two *giornate* as compared to thirty-six by Masaccio alone in the scene directly below it. Indeed, the *Raising of the Son of Theophilus* has the copiousness and variety of Gentile da Fabriano's famous *Adoration of the Magi* of 1423, translated into the language of the new movement.

6 *lo 'ncerto altrui mostrar visibile*

7 Such deliberate distortion is found in the work of architects and painters. For example, for his façade of the Florentine

Ospedali degli Innocenti, Brunelleschi took the precaution of making his beautiful *tonti* vertical ovals, instead of perfect circles. Simarlarly in his famous fresco cycle for the vast choir of Santa Maria Novella, where he illustrated the Lives of the Virgin and Saint John the Baptist, Domenico Ghirlandaio painted the Banquet of Herod; in a prominent position in the foreground of this scene,whose position is high above the floor causing its space to constrict in a way that distorts the architectural setting as well as the figures, what has Domenico done but introduced a dwarf!

8 We cannot help but think of the famous story, best known in a version composed by Brunelleschi's biographer Antonio Manetti, of *La Novella del Grasso Legnaiuolo*, or the *Fat Woodworker*, in which the architect of the vanishing point performs the miraculous trick of making the woodworker, an otherwise abundantly tangible fact, disappear into thinnest nowhere. Counterfeiting his voice, instructing the victim's friends, even controlling the locale, he persuades the woodworker that he never was, that his previous life was but a dream, that he is in fact another id. With an innocent-seeming "Good morning, Matthew," the artist has the astonishing necromantic power to make one thing into another, to be or not to be. And so, after admitting that "these are certainly new things," the uncertain woodworker, who hitherto enjoyed a vague existence as "the fat one," finds his happy end in Hungary, that is, far, far out of sight.

Selected Bibliography

Alberti, L. B. *On Painting and On Sculpture*, ed., trans., and with intro. and notes by C. Grayson. London, 1972.

Baldini, U. "Dalla Scoperta di San Giovenale a quelle della Brancacci," in *Gli Uffizi* (*Studi e Ricerche*, no. 5: *I pittori della Brancacci agli Uffizi*), pp. 11–18.

Baldini, U., and O. Casazza. *The Brancacci Chapel*. New York, 1992.

Baxandall, M. *Painting and Experience in the Fifteenth-Century: A Primer on the Social History of Pictorial Style.* Oxford, 1972.

Beck, J. "'Fatti di Masaccio . . . ,'" *In Memoriam Otto J. Brendel: Essays in Archaeology and the Humanities*, ed. L. Bonfante and H. von Heintze with C. Lord. Mainz, 1976, pp. 211–14.

Beck, J. *Masaccio: The Documents*. Locust Valley (N.Y.), 1978.

Berenson, B. *Florentine Painters of the Renaissance*. New York, 1896.

Berti, L., ed. *La Chiesa di Santa Maria del Carmine a Firenze*. Florence, 1992.

Berti, L., *Masaccio*. State College (Pa.), 1967.

Berti, L., and U. Baldini. *Filippino Lippi*. Florence, 1975.

Berti, L., and R. Foggi. *Masaccio: Catalogo completo*. Florence, 1989.

Berti, L., and A. Paolucci. *L'Età di Masaccio: Il primo Quattrocento a Firenze*. Florence, 1990.

Bocci Pacini, P. "Umanesimo in Masolino," in *Gli Uffizi* (*Studi e Ricerche*, no. 5: *I pittori della Brancacci agli Uffizi*), pp. 19–32.

Borsook, E. *The Mural Painters of Tuscany*, 2nd ed., rev. and enl. Oxford, 1980.

Boskovits, M. "'Giotto Born Again': Beiträge zu den Quellen Masaccio." *Zeitschrift für Kunstgeschichte*, XXIX (1966), pp. 51–61.

Boskovits, M. "Il Percorso di Masolino: precisazioni sulla cronologia e sul catalogo." *Arte Cristiana*, LXXV (1987), pp. 47–66.

Branca, V., ed. *Mercanti scrittori: ricordi nella Firenze tra medioevo e rinascimento*. Milan, 1986.

Brunelleschi, F. *Sonetti di Filippo Brunelleschi*, intro. by G. Tanturli and with textual notes by D. de Robertis. Florence, 1977.

Caneva, C. "L'Ultimo della Brancacci," in *Gli Uffizi* (*Studi e Ricerche*, no. 5: *I pittori della Brancacci agli Uffizi*), pp. 85–92.

Casazza, O. "Al di là dell'immagine," in *Gli Uffizi* (*Studi e Ricerche*, no. 5: *I pittori della Brancacci agli Uffizi*), pp. 93–101.

Casazza, O. "Il Ciclo delle storie di San Pietro e la 'Historia Salutis': Nuova lettura della Cappella Brancacci." *Critica d'Arte*, LI (1986), pp. 69–84.

Casazza, O. "La Grande gabbia architettonica di Masaccio." *Critica d'Arte*, LIII (1988), pp. 78–97.

Christiansen, K. "Some Observations on the Brancacci Chapel Frescoes after Their Cleaning." *Burlington Magazine*, CXXXIII (1991), pp. 5–20.

Cole, B. *Masaccio and the Art of Early Renaissance Florence*. Bloomington (Ind.), 1980.

Debold von Kritter, A. *Studien zum Petruszyklus in der Brancacci Kapelle*. Berlin, 1975.

Fremantle, R. "Masaccio e l'antico." *Critica d'Arte*, CIII (1969), pp. 39–56.

Hartt, F. "Art and Freedom in Quattrocento Florence." *Essays in Memory of Karl Lehmann*, ed. L. Freeman Sandler. Locust Valley (N.Y.), 1964, pp. 114–131.

Hills, P. *The Light of Early Italian Painting*. New Haven and London, 1987.

Jacobsen, W. "Die Konstruktion der Perspektive bei Masaccio und Masolino in der Brancacci Kapelle." *Marburger Jahrbuch für Kunstwissenschaft*, XXI (1986), pp. 73–92.

Joannides, P. "Masaccio, Masolino and 'Minor' Sculpture." *Paragone*, XXXVIII (1987), pp. 3–24.

Longhi, R. "Fatti di Masolino e di Masaccio." *Critica d'Arte*, V (1940), pp. 145–91.

Manetti, A. *Vite di XIV uomini singhulary in Firenze dal MCCCC innanzi*, ed. G. Milanesi. Florence, 1887.

Meiss, M. "Masaccio and the Early Renaissance: The Circular Plan." *Studies in Western Art (Acts of the Twentieth International Congress of the History of Art)*. Princeton, (N.J.), 1963, vol. II, pp. 123–45.

Meller, P. "La Cappella Brancacci: problemi ritrattistici e iconografici." *Acropoli*, III, (1960–61), pp. 186–227, 273–312.

Micheletti, E. *Masolino da Panicale*. Milan, 1959.

Molho, A. "The Brancacci Chapel: Studies in Its Iconography and History." *Journal of the Warburg and Courtauld Institutes*, XL (1977), pp. 50–98.

Offner, R. "Light on Masaccio's Classicism." *Studies in the History of Art Dedicated to W. Suida on His Eightieth Birthday*, London, 1959, pp. 66–72.

Ozment, S. Magdalena and Balthasar: *An Intimate Portrait of Life in Sixteenth-Century Europe Revealed in the Letters of a Nuremberg Husband and Wife*. New Haven and London, 1989.

Pandimiglio, L. *I Brancacci di Firenze: Felice di Michele vir clarissimus e una consorteria* (*Quaderni del restauro* no. 3). Turin, 1987.

Pope-Hennessy, J. *Donatello's Relief of the Ascension with Christ Giving the Keys to Saint Peter.* London, 1949.

Procacci, U. "Sulla Cronologia delle opere di Masaccio e di Masolino tra il 1425 e il 1428." *Rivista d'arte*, XXVIII (1953), pp. 3–55.

Procacci, U. "L'Incendio della chiesa del Carmine del 1771: La Sagra di Masaccio; gli affreschi della cappella di San Giovanni." *Rivista d'arte*, XIV (1932), pp. 141–232.

Procacci, U. "Nuove testimonianze su Masaccio." *Commentari*, XXVII (1976), pp. 223–37.

Procaciolli, P., ed. *La Novella del Grasso Legnaiuolo.* Parma, 1990.

Rossi, P. "Lettura del Tributo di Masaccio." *Critica d'Arte*, LIV (1989), pp. 39–42.

Shulman, K. *Anatomy of a Restoration: The Brancacci Chapel.* New York, 1991.

Sisi, C. *Michelangelo e i maestri del Quattrocento.* Florence, 1985.

Trinkaus, C. *In Our Image and Likeness: Humanity and Divinity in Italian Humanist Thought*, 2 vols. London, 1970.

Vasari, G. *Lives of the Most Excellent Painters, Sculptors and Architects*, trans. G. Du C. de Vere and intro. by K. Clark. New York, 1979.

Verdon, T. "La Sant'Anna Metterza: riflessioni, domande, ipotesi," in *Gli Uffizi* (*Studi e Ricerche*, no. 5: *I pittori della Brancacci agli Uffizi*), 1989, pp. 33–58.

Volponi, P., and L. Berti. *L'opera completa di Masaccio.* Milan, 1968.

Voragine, J. de. *The Golden Legend*, trans. and ed. G. Ryan and H. Ripperger. New York, 1941.

Wakayama, E. "Lettura iconografica degli affreschi della Cappella Brancacci: analisi dei gesti e della composizione." *Commentari*, XXIX (1978), pp. 72–80.

Watkins, L. "Technical Observations on the Frescoes of the Brancacci Chapel." *Mitteilungen des Kunsthistorisches Institutes in Florenz*, XVII (1973), pp. 65–74.

Welliver, W. "Narrative Method and Narrative Form in Masaccio's *Tribute Money.*" *Art Quarterly*, n. s. I (1977), pp. 40–58.

Glossary of Fresco Terms

Affresco (in English usage, "fresco"). Painting with pigments dissolved in water on freshly laid plaster. As both plaster and paint dry, they become completely integrated. Known as the "true" fresco (or *buon* fresco), this technique was most popular from the late thirteenth to the mid-sixteenth centuries.

Arriccio. The preliminary layer of plaster spread on the masonry. The sinopia is executed on this layer. The *arriccio* was left rough so that the final, top layer (see *intonaco*) might more easily adhere to it.

Cartone (in English usage, "cartoon"). The artist's final drawing on paper or cloth of the main lines of the composition; it is sometimes, but not always, equal in size to the wall area to be painted. (Several cartoons might be used to create one large image.) The cartoon was laid against the wall over the final, freshly laid plaster on which the artist would paint. Its outlines were incised on the plaster by pressure from a stylus to guide the artist in painting. This procedure was common in the sixteenth century. The *spolvero* technique (see below) was commonly used as well.

Giornata. The patch of *intonaco* to be painted as part of a regular, sequential—hence 'daily'—task, not necessarily in one day. The artist decided in advance the size of the surface he would paint and laid on top of the *arriccio* only the amount of fresh *intonaco* needed for his work. The joinings are usually discernible upon a close examination of the painted surface, and they disclose the order in which the patches were painted, because each successive patch slightly overlaps the preceding one.

Intonaco. The final, smooth layer of plaster for the finished painting. It was made from lime and sand and laid in sections.

Mezzo fresco. Painting on partially dry plaster. The pigment penetrates the plaster less deeply than with the "true" fresco method, and the carbonation is less extensive. *Mezzo* fresco was a popular procedure in the sixteenth and later centuries.

Pontata. *Intonaco* spread in wide bands that correspond to successively lower stages of the scaffold. The painter frequently laid some preparatory colors on these large surfaces as they were drying, but he usually spread his final colors after the *intonaco* had dried. This is largely, then, a *secco* technique.

Secco (literally, "dry"). Painting on plaster that has already dried. The colors are mixed with an adhesive or binder to attach them to the surface to be painted. The binding medium may be made from various substances, such as tempera. Tempera (the addition of egg yolk to pigments) was commonly used to complete a composition already painted in fresco. Because the pigment and the dry wall surface do not become thoroughly united, as they do in "true" fresco, *secco* mural paintings tend to deteriorate and flake off the walls more rapidly.

Sinopia. Originally a red ochre named after Sinope, a town on the Black Sea that was well known for its red pigments. In

fresco technique the term is used for the final preparatory draw-
ing on the *arriccio*, which was normally executed in red ochre.

Spolvero. An early method (see *cartone*) of transferring the
artist's drawing onto the *intonaco*. After drawings as large as the
frescoes were made on paper, their outlines were pricked, and
the paper was cut into pieces the size of each day's work. After
the day's patch of *intonaco* was laid, the corresponding drawing
was placed over it and "dusted" with a cloth sack filled with
charcoal powder, which passed through the tiny punctured holes
to mark the design on the wall. This method was most popular
in the second half of the fifteenth century.

Stacco. The process of detaching a fresco painting from the
wall by removing the pigment and the *intonaco*. Usually an ani-
mal glue is applied to the painted surface and then two layers of
cloth (calico and canvas) are applied, left to dry, and later
stripped off the wall, pulling the fresco with them. It is taken to
a laboratory, where the excess plaster is scraped away and anoth-
er cloth is attached to its back. Finally, the cloths on the face of
the fresco are carefully removed. The fresco is then ready to be
mounted on a new support.

Strappo. The process by which a fresco is detached from a
wall when the plaster on which it is painted has greatly deterio-
rated. *Strappo* takes off only the color layer with very small
amounts of plaster. It is effected by the use of a glue consider-
ably stronger than that used in the *stacco* technique, but the pro-
cedure that follows is identical. After certain frescoes are
removed by the means of *strappo*, a colored imprint may still be
seen on the plaster remaining on the wall. This is evidence of the
depth to which the pigment penetrated the plaster. These traces
of color are often removed by a second *strappo* operation on the
same wall.